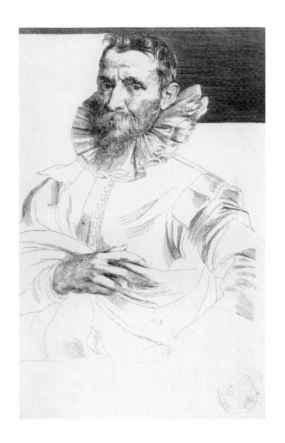

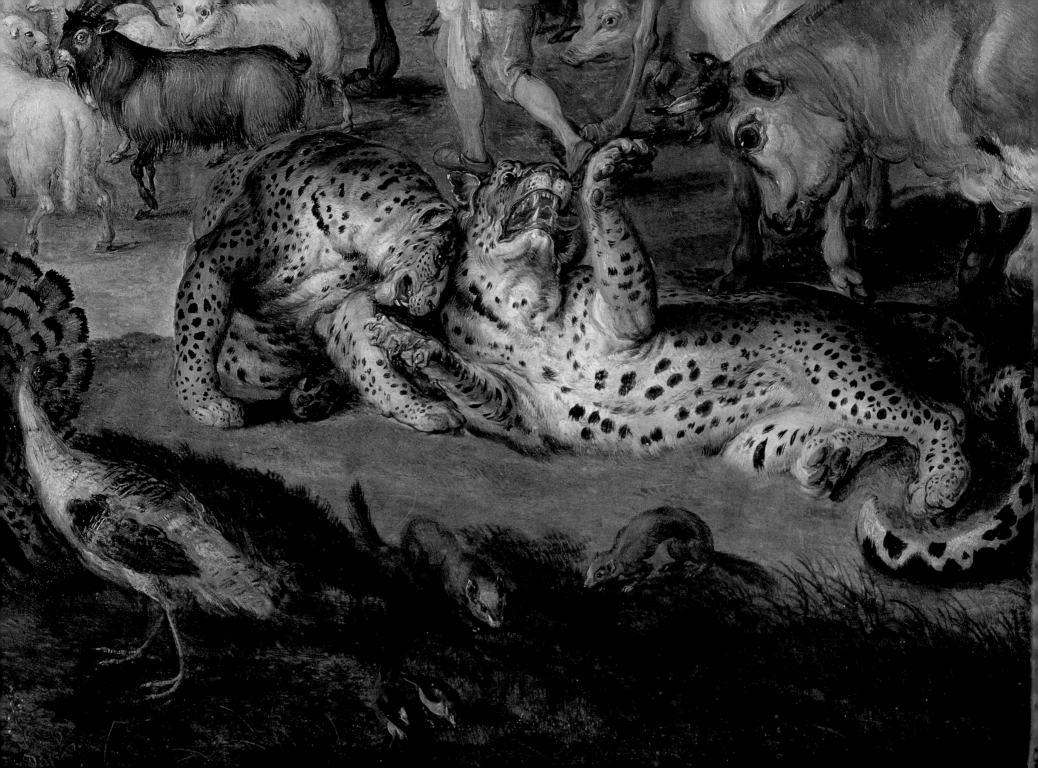

JAN BRUEGHEL THE ELDER

The Entry of the Animals into Noah's Ark

Arianne Faber Kolb

THE J. PAUL GETTY MUSEUM, LOS ANGELES

© 2005 J. Paul Getty Trust

Getty Publications
1200 Getty Center Drive, Suite 500
Los Angeles, California 90049-1682
www.getty.edu

Christopher Hudson, *Publisher*
Mark Greenberg, *Editor in Chief*

Mollie Holtman, *Series Editor*
Abby Sider, *Copy Editor*
Jeffrey Cohen, *Designer*
Suzanne Watson, *Production
 Coordinator*
Christopher Foster, Lou Meluso,
Charles Passela, Jack Ross,
 Photographers

Typesetting by Diane Franco
Printed in China by Imago

Library of Congress
Cataloging-in-Publication Data

Kolb, Arianne Faber
 Jan Brueghel the Elder : The entry
 of the animals into Noah's ark /
 Arianne Faber Kolb.
 p. cm. — (Getty Museum
 studies on art)
 Includes bibliographical references
 and index.
 ISBN 0-89236-770-9 (pbk.)
 1. Brueghel, Jan 1568–1625. Noah's
 ark (J. Paul Getty Museum)
 2. Noah's ark in art. 3. Painting—
 California—Los Angeles.
 4. J. Paul Getty Museum. I. Title.
 II. Series.
 ND673.B72A7 2004
 759.9493— dc22
 2005014758

Cover and frontispiece:
Jan Brueghel the Elder (Flemish,
1568–1625), *The Entry of the Animals
into Noah's Ark*, 1613 [full painting
and detail]. Oil on panel, 54.6 ×
83.8 cm (21½ × 33 in.). Los Angeles,
J. Paul Getty Museum, 92.PB.82.

Page i:
Anthony van Dyck (Flemish,
1599–1641) and an unknown
engraver, *Portrait of Jan Brueghel
the Elder*, before 1621. Etching and
engraving, second state, 24.9 ×
15.8 cm (9¾ × 6¼ in.). Amsterdam,
Rijksmuseum, Rijksprentenkabinet,
RP-P-OP-11.113.

Contents

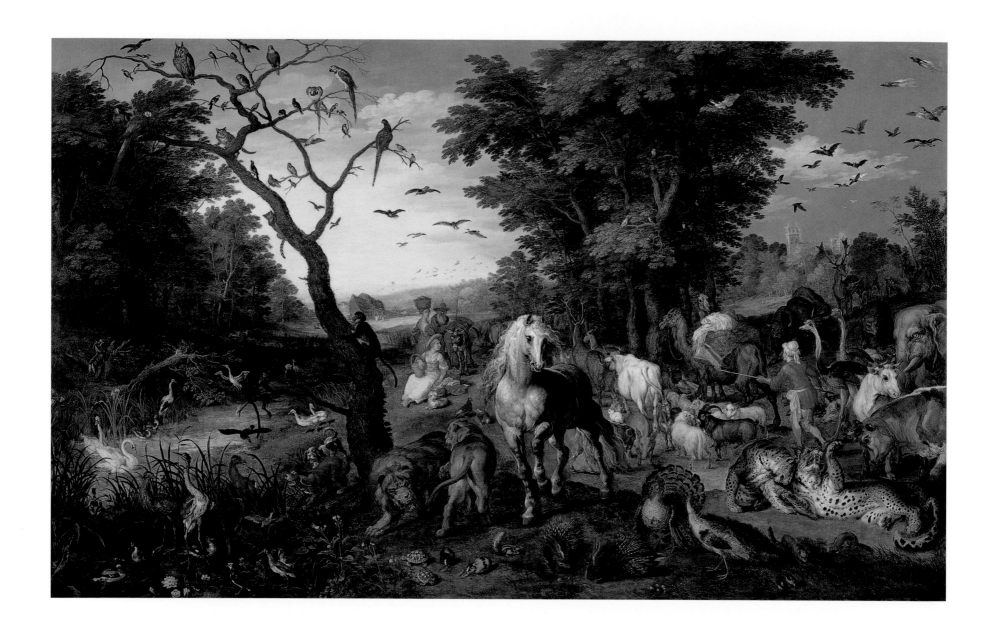

The Painted Paradise

I n *The Entry of the Animals into Noah's Ark* [FIG-URE 1], painted in 1613, the extent of God's creative power is magnificently displayed in the copious array of species. On a relatively small panel surface (21½ × 33 inches), Jan Brueghel the Elder depicts numerous animals and birds with remarkable accuracy and a high degree of finish. He demonstrates his accomplished miniaturist technique, particularly in the description of the small species. Brueghel articulates every minute hair on the guinea pig and every variegated needle on the porcupine, as well as the intricate patterns on the tortoise's shell [FIGURE 2] and the different shades of red, blue, and yellow in the parrots' feathers [FIGURE 3]. He sometimes provides a glimpse of the ducks' and swans' feet beneath the water and even suggests the ripples in the water created by these birds' movements. One can also identify the different types of birds flying in the distant sky, including birds of paradise, hawks, and ducks.

With paintings such as *The Entry of the Animals into Noah's Ark*, Brueghel popularized the "paradise landscape," a new subgenre of landscape painting in the early seventeenth century, which typically represents episodes from Genesis [see "Brueghel and the Invention of the Paradise Landscape," pp. 47–60]. In Brueghel's works, numerous exotic and native European species coexist harmoniously in a lush landscape setting. He inherited his specialization in landscapes from his father, Pieter Bruegel the Elder (1525–1569), the most important Flemish painter of his time. As his son, Jan was born with a relatively high status in society. After six years in Italy, in 1596 he established himself as the leading landscape and still-life painter of Antwerp, his native city. While in Rome and Milan, Brueghel painted many landscapes and flower paintings for Cardinal Federico Borromeo, whom he continued to serve until the end of his life in 1625. In 1606 he was appointed court painter to the Archduke Albert of Austria (1559–1621) and the Infanta Isabella of Spain (1566–1633), who cultivated a magnificent menagerie in Brussels that would provide him with live models for his paintings. Thus, Brueghel inhabited the worlds of the elite burgher class of Antwerp, the court of Brussels, and the upper echelons of the Italian clergy [FIGURE 4].

Figure 1
Jan Brueghel the Elder
(Flemish, 1568–1625),
*The Entry of the Animals
into Noah's Ark*, 1613.
Oil on panel, 54.6 ×
83.8 cm (21½ × 33 in.).
Los Angeles, J. Paul Getty
Museum, 92.PB.82.

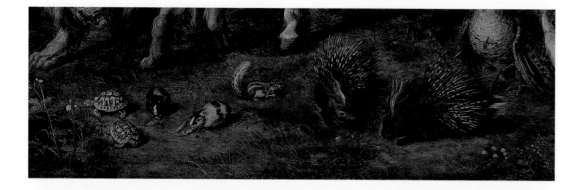

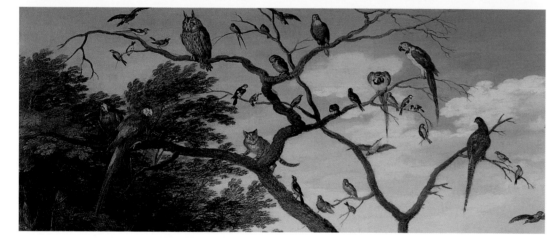

Figures 2 and 3
Jan Brueghel the Elder,
*The Entry of the
Animals into Noah's Ark*
[details of Figure 1].

opposite
Figure 4
Peter Paul Rubens (Flemish,
1577–1640), *Portrait of
Jan Brueghel the Elder and
His Family*, circa 1612–13.
Oil on panel, 125 × 95.2 cm
(49¼ × 37½ in.). London,
Courtauld Institute of Art
Gallery, The Samuel Courtauld
Trust, P.1978.PG.362.

Figure 5
Jan Brueghel the Elder,
*Vase of Flowers with Jewel,
Coins, and Shells*, 1606.
Oil on panel, 65 × 45 cm
(25⅝ × 17¾ in.). Milan,
Pinacoteca Ambrosiana, 66.

Brueghel's paintings evidently appealed to numerous patrons, who shared his particular interest in nature.[1] He dazzled their senses with his paradise landscapes, which depict every manner of fish, bird, and quadruped, and his sumptuous bouquets, which include a copious variety of flowers from every season [FIGURE 5]. Brueghel's specialization in flowers and animals demonstrates his encyclopedic approach to exploring the visible world. He devoted close and nearly equal attention to all aspects of nature, whether animals, flowers, fruit, trees, mountains, seas, or streams.

The novelty of Brueghel's paradise landscapes lies not only in the impressive assemblage of animals studied mainly from life but also in their presentation as both figures of a religious narrative and as subjects of a scientific order. An examination of these various approaches forms the basis of this book. The two main elements to be considered are the strategies employed in the artistic representation of animals, and the scientific and cultural attitudes of the late sixteenth and early seventeenth centuries, in particular the emphasis on empirical evidence as opposed to inherited tradition in natural historical inquiry. Brueghel's landscapes were created during a period that produced some of the first scholarly catalogues and encyclopedias, in particular the illustrated natural history catalogues by the prominent sixteenth-century naturalists Conrad Gesner and Ulisse Aldrovandi. Was Brueghel's production of *The Entry of the Animals into Noah's Ark* an intuitive response to his ability to render species and vegetation naturalistically, or did it reflect the interests of his patrons and the European scholarly and courtly culture, or both? We shall see how Brueghel's particular approach to nature imagery and landscapes, together with the classifying culture of the time, contributed to the unique

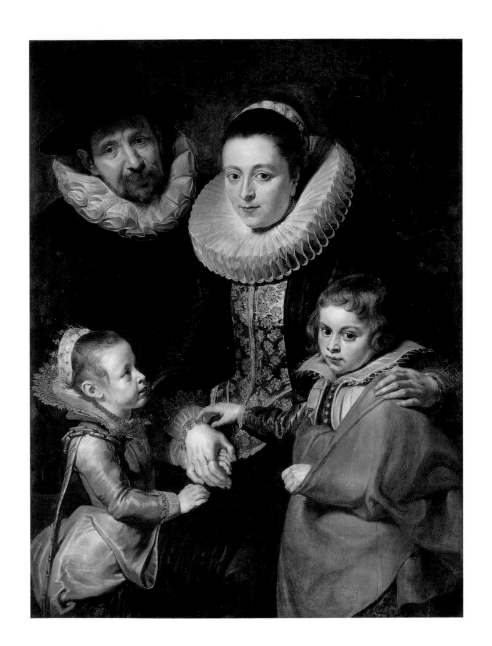

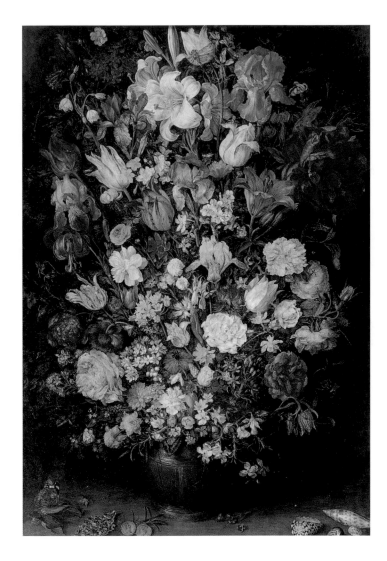

character of this work, which functions as a visual catalogue of nature. In this work, the linguistic mode of the natural history encyclopedia, in which the illustrations are accompanied by texts, was supplanted by purely visual descriptions. Thus Brueghel translated the written information provided by the catalogue into a pictorial format: he replaced words with images.

An interdisciplinary approach to the study of Brueghel's *Entry of the Animals into Noah's Ark* is necessary, because the nature of the subject matter requires an exploration of Renaissance zoology, religious views on nature, and the culture of collecting and cataloguing animals and natural specimens. Furthermore, the written word played a central role in the quest for true knowledge of nature, whether in the Bible, the encyclopedia, or the catalogue.[2] Textual knowledge is another thread that ties Brueghel's paradise landscapes together. This book will also briefly explore the tradition of animal and landscape painting that constitutes Brueghel's artistic grounding as well as the development of Brueghel's paradise landscapes. His encounters with different patrons from ecclesiastic and courtly realms demonstrate the role that the cultural context played in the tools he developed for his paintings. The chronology of Brueghel's works reveals his growing impulse to catalogue species, with *The Entry of the Animals into Noah's Ark* representing the culmination of his efforts to achieve a visual equivalent to natural historical classification.

This book will attempt to identify the first owner of the painting. Unfortunately, no documentary evidence of its original ownership exists. In a letter to Cardinal Federico Borromeo dated April 22, 1611, Brueghel briefly mentions a painting of Noah's Ark, but does not indicate for whom he was painting it.[3] Until now, the earliest known provenance for the painting was the collection of Peeters d'Artselaer de Cleydael in Antwerp during the late eighteenth century. Baron H. J. Stier d'Artselaer of Antwerp inherited it between 1792 and 1822. At the sale of the baron's collection in 1822, M. L. J. Nieuwenhuys bought the painting. Thereafter, it entered private collections in Vienna and Switzerland, eventually ending up in the collection of Robert Smith of Washington, D.C., from whom the J. Paul Getty Museum acquired it in 1992.

The Animals Entering the Ark as a Subject

Brueghel captures the moment in the biblical story of Noah and the Flood (Genesis 7:7–9) when Noah's family and the animals assemble and proceed to the ark, seen here in the far background:

> Noah and his sons and his wife and his sons' wives with him went into the ark, to escape the waters of the flood. Of clean beasts, and of beasts that are not clean, and of fowls, and of everything that creepeth upon the earth. There went in two and two unto Noah into the ark, the male and the female, as God had commanded Noah.

God spared Noah and his family by forewarning them about the impending deluge, which he unleashed in his wrath against the sins of humanity and the corruption of the earth. Noah obeyed God's commandment and built an ark to save his family and a selection of species during this great flood. In accordance with the story, Brueghel depicts most of the animals in pairs. His painting follows the biblical text literally by distinguishing between the

4

"beasts," represented predominantly on the right side of the composition, and the "fowl," on the left.

Although Brueghel obscures the principal motif of the ark by placing it in the background, he links it to the animals in the foreground. One's eye follows the parade of animals, which are urged by the shepherd toward Noah and his family in the middle ground, and ultimately toward the ark behind them in the far distance. Their movement away from the viewer implies their imminent departure. As Brueghel knew from his years in Rome around 1592–94, Michelangelo (1475–1564), in his *Deluge* painted on the ceiling of the Sistine Chapel a century earlier (1508–12), placed the ark in the background in order to concentrate on the plight of the drowning sinners.[4] Brueghel, on the other hand, used the device to call attention to the vast array of species. His moralizing message was not as severe as that of his predecessors, who emphasized man's sin. Brueghel's luminous painting reflects the more optimistic outlook of the Catholic Counter-Reformation, in particular the philosophy of his patron Cardinal Federico Borromeo (1564–1631). Their aim was not to arouse fear in the worshiper, but to rejoice in the positive aspects of the biblical story. In his vivid description of nature, Brueghel invites the beholder to celebrate the beauty and variety of God's creations. The ark's symbolism was especially relevant during the Counter-

5

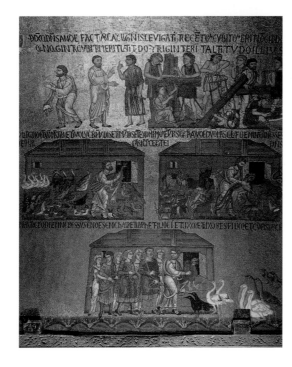

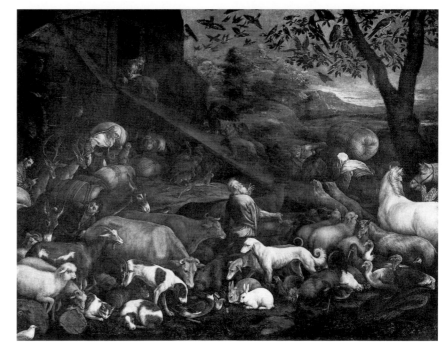

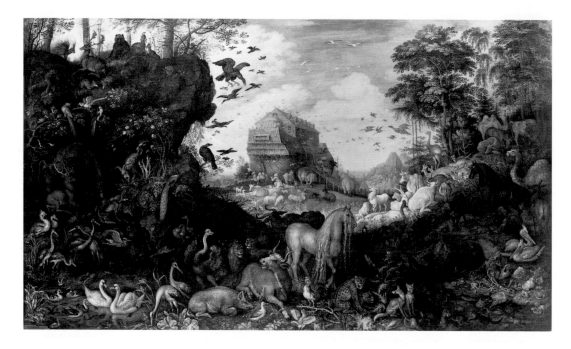

Figure 8
Roelandt Savery (Flemish, 1576–1639), *The Entry of the Animals into Noah's Ark*, 1620. Oil on panel. Dresden, Gemäldegalerie Alte Meister, Cat. 1930, 932. Photo: Kramer.

Reformation, when the idea was promoted that only the Catholic Church could provide salvation, quite as Noah alone had saved mankind. The story helped confirm the church's authority, since the ark was a symbol of the church and Noah was a prefiguration of Christ.[5]

In Christian art, the Flood and the Sacrifice of Noah were rather common subjects, but the representation of animals entering the ark occurred rarely and first appeared in Italy. The twelfth-century mosaic cycle in the San Marco Basilica in Venice is evidently the first and only monumental work to represent the Entry of the Animals into Noah's Ark [FIGURE 6]. The artist devotes three scenes to the embarkation, each depicting a different category of species. Like Brueghel, the artist distinguishes

between the fowl and the beasts mentioned in the Bible. The subject reappears during the second half of the sixteenth century in Venice, when a few prominent patrons commissioned scenes of Noah's Ark from Jacopo Bassano and his workshop. In Jacopo Bassano's painting *The Animals Entering Noah's Ark* [FIGURE 7], mainly domestic and farm animals crowd the foreground as they merge toward the ark, which dominates the upper left side of the composition.

Brueghel was apparently the first artist in the Netherlands to paint the subject of the animals entering Noah's Ark. While it occurs in a handful of sixteenth-century Netherlandish prints, most notably the engravings of Hans Bol (1534–1593) and Maarten de Vos (1531–1603), it does not become prevalent in northern painting until after Brueghel produced his groundbreaking work.[6] Hieronymus Bosch's *Noah's Ark* (circa 1514, Boymans-van Beuningen Museum, Rotterdam) represents the animals leaving the ark after the flood. Emperor Rudolf II's court painter Roelandt Savery, whom Brueghel probably met in Prague in 1604, did not paint *The Entry of the Animals into Noah's Ark* until 1620 [FIGURE 8].[7] Savery may have drawn his inspiration from Brueghel, but he certainly did not copy his composition, which appears more arbitrarily constructed than Brueghel's carefully laid out landscape. Like Brueghel, Savery represents many of the same species in pairs, but they are quite different in appearance. The correlation to the species in Rudolf's menagerie implies that Savery probably studied the animals from life. However, unlike Brueghel, Savery endows them with a somewhat caricatural quality.

Thus, Brueghel's accurate description of animals within a paradise landscape did not have any direct prece-

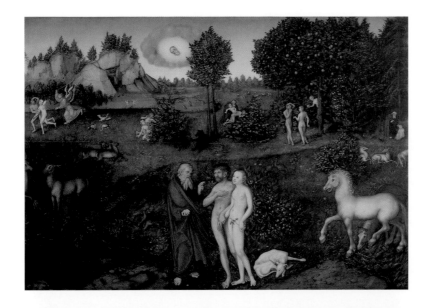

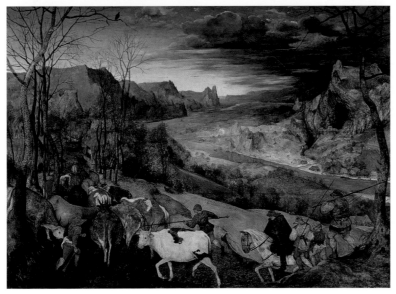

dent. Despite having a common biblical subject matter, the few earlier paradise landscapes by the northern Renaissance artists Hieronymus Bosch (1450–1516) and Lucas Cranach the Elder (1452–1553) differ from Brueghel's paintings in their imaginary and rather naive representation of animals [FIGURE 9].[8] For example, they tend to include the mythical unicorn, a creature that Brueghel never depicted. In this respect, his representations have more in common with the naturalistic independent animal studies by artists such as the German Renaissance painter Albrecht Dürer (1471–1528) [see FIGURE 37]. However, such images display different approaches and functions from Brueghel's paradise landscapes. Dürer's monumental representations have an empirical value because of their subjects. Like other forms of painting from life, including portraits or cityscapes, they sometimes have a documentary status, especially when inscribed with dates and identifications. Brueghel's presentation of a wide range of species within an artificial composition, on the other hand, was not meant to function as a record of a specific moment.

Another significant difference between Brueghel's representation of animals and that of earlier northern Renaissance landscapists, including his father, is those artists' use of them as symbolic or decorative elements. The abundant species in Brueghel's paintings usually do not have an individual symbolic value, but represent the subject matter as a whole, e.g., the birds in the *Allegory of Air* [see FIGURE 41]. Jan's precise and lifelike depictions contrast with his father's representations, whose "naturalness" is evoked by their complete integration within the landscape. The elder Bruegel was not necessarily interested in depicting specific species, but rather in painting com-

7

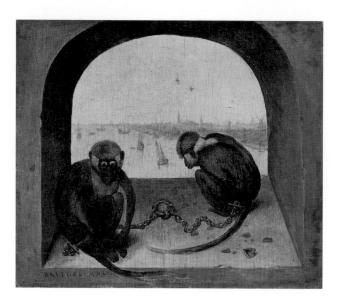

mon and identifiable types of animals, such as the cows
in *The Return of the Herd*, which blend harmoniously into
the brownish tones of the surrounding nature [FIGURE
10]. However, Pieter Bruegel's painting *Two Chained
Monkeys*, his only work with animals as the main subject
matter, does represent a specific type of African monkey,
the red-headed colobus [FIGURE 11].⁹ Similarly, Jan accu-
rately depicts a *Cercopithecus preussi* in his *Entry of the
Animals into Noah's Ark* [FIGURE 12]. While the meaning
of Jan's animals stems from their representation as identi-
fiable specimens, the monkeys in Pieter's painting also
serve an emblematic function. The traditional interpreta-
tion is that they symbolize folly because they relinquished
their freedom in exchange for the fleeting enjoyment
of a hazelnut. Thus, by focusing on the monkeys' chained
condition or entrapment, Pieter also emphasizes their

subjectivity. The precise surface description of Jan's crea-
tures underscores their objectivization.

This descriptive approach constitutes the basis of Jan
Brueghel's depiction of nature. Interestingly, Brueghel
often collaborated with figure painters, such as Peter Paul
Rubens and Hendrik van Balen, thereby allowing him to
focus exclusively on the landscape, flora, and fauna. Such
a specialized practice, which often resulted in a division
of labor, had been common among Flemish landscape
painters, such as Joachim Patinir, since the early sixteenth
century. Since Brueghel did not collaborate with a figure
painter in *The Entry of the Animals into Noah's Ark*,
this aspect of his working method shall not be discussed
in detail. Rather, Brueghel's innovative representation
of an extraordinary assortment of species will be explored
in the following pages.

The Descriptive Process:
Brueghel's Representation of Animals

In order to determine Brueghel's method of representing animals and his development of a pictorial system of classification, one must first examine the process he employed to arrive at his images. Drawings and oil sketches played a critical role in his description of animals *ad vivum*. Such studies probably account for the precision and confidence with which Brueghel painted the species in *The Entry of the Animals into Noah's Ark* [FIGURE 1].

From the outset, Brueghel apparently had a clear conception of the painting's composition, since his underdrawing reveals a preliminary outline of the prominent landscape elements, the ark, and the larger animals and figures.[10] He adhered closely to this drawing in the final painting stage, making only a few slight changes, such as the shifting of the horse's ears [FIGURE 13]. His painstaking working process involved the application of numerous layers of paint. Upon close inspection, Brueghel's steady brushstrokes and sureness of touch reveal his confidence in depicting a wide range of animals.

Brueghel most likely had firsthand knowledge of some of the exotic species, since they do not mimic the

Figure 13
Infrared reflectograph
of *The Entry of the Animals
into Noah's Ark* [detail of
Figure 1], Los Angeles, J. Paul
Getty Museum. Photo:
Yvonne Szafran, Department
of Paintings Conservation.

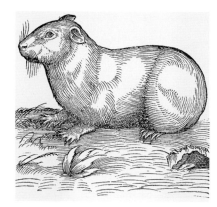

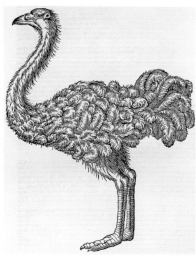

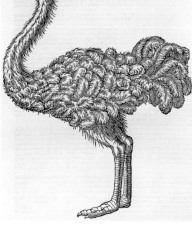

Figure 14
Guinea Pig, from Conrad
Gesner (Swiss, 1516–1565),
Historia animalium (vol. 1,
De Quadrupedus viviparis),
1551. Woodcut. Los Angeles,
Research Library, The
Getty Research Institute.

Figure 15
Ostrich, from Conrad Gesner,
Historia animalium (vol. 3,
De Avium natura), 1555.
Woodcut. Los Angeles,
Research Library, The
Getty Research Institute.

Figure 16
Jan Brueghel the Elder, *Ostrich*,
circa 1613. Pen and brown ink
and gouache and watercolor
on cream paper, 20.5 × 14.2 cm
(8 × 5½ in.). Sale catalogue,
Sotheby's, New York, January
20, 1982. Private collection.

illustrations in the natural history encyclopedias of the
time. Many of Ulisse Aldrovandi's and Conrad Gesner's
illustrations of these creatures, such as the guinea pig,
seem awkward and generic by comparison [FIGURE 14].
Brueghel enlivens the representation of the guinea
pigs in *The Entry of Animals into Noah's Ark* by showing
them in the act of eating peas. Gesner's illustration of
an ostrich features the exaggerated articulation of fluffy
feathers [FIGURE 15]. The artist had apparently never
seen one and drew stylized feathers over the correct out-
line. Brueghel, on the other hand, based the ostrich in his
painting on his own direct observation, as demonstrated
by his drawing in gouache, watercolor, and pen and
brown ink of the full body of the bird as well as its head
[FIGURE 16]. Brueghel was evidently impressed by the
height of the ostrich, for he inscribed its measurements
in the upper right: *9 voeten hooghe* (nine feet high).
This inscription implies that he saw the bird in person.
The color notations articulate what he apparently could
not accomplish with the faint watercolors, suggesting
that he may not have had enough time to carefully color
the ostrich if, indeed, he had studied a live specimen.
Brueghel's inclusion of such notations reveals the
important role that color often played in the description
of a species and demonstrates his application of artistic
vocabulary to the observation of nature. Overall,
Brueghel's representations of animals have nothing in
common with the typically generic subjects of the natural
history woodcuts. He described the species in *The Entry
of the Animals into Noah's Ark* with such accuracy that
they can all be precisely identified. This is rather
remarkable considering the minute size of some of the
birds in the painting.

Figure 17
Jan Brueghel the Elder,
*Oil Sketch of Monkeys,
Donkeys, and Cats*, circa 1613.
Oil on panel, 34.2 ×
55.5 cm (13½ × 21⅞ in.).
Vienna, Kunsthistorisches
Museum, 6988.

Besides Brueghel's drawing of the ostrich, one other known preparatory study for the painting exists — an oil sketch on panel in the Kunsthistorisches Museum, Vienna, includes numerous studies of monkeys, donkeys, and cats [FIGURE 17]. *Cercopithecus preussi*, the same monkey that appears in *The Entry into Noah's Ark* and in the oil sketch, comes from Boiko, Africa, a colony of the Portuguese in the fifteenth century and later a Netherlandish trading post.[11] It therefore would have been likely that such a monkey was imported to the Netherlands. Brueghel certainly studied the animal from life, since it does not appear in any natural history or artistic source. The other monkey in the oil sketch is a *Cebus apela*, called a brown capuchin because of the wedge-shaped tuft on its head; it reappears in *Adam and Eve in Paradise* of 1615 in the Mauritshuis, The Hague [see FIGURE 76].[12] Brueghel

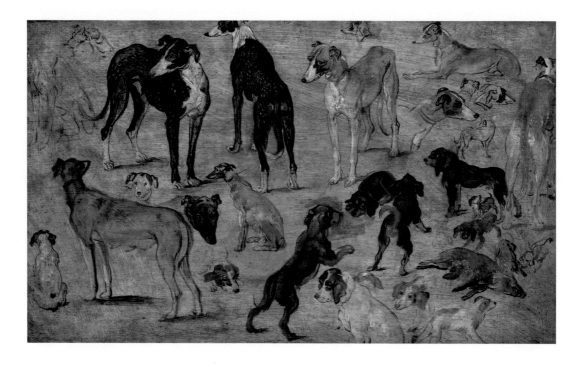

12

painted the entire bodies of the *Cercopithecus preussi*, the donkey, and the cat with careful attention to their coloration and hair. He also made detailed studies of their heads nearby, recalling his drawing of the ostrich. His pure outline drawings of the donkey examine it from different angles and in several poses. Brueghel demonstrates the various stages of representing an animal, ranging from the basic delineation of its contours to its modeling and coloring. The overlapping studies of the cat on the right display an interesting technique; each form evolves into another in a fluid and natural manner.

Brueghel produced other such oil sketches of animals, most notably one of dogs, attempting to replicate the experience of seeing a species firsthand [FIGURE 18].[13]

The animal sketches were most likely painted on panel for the sake of preservation. The combination of their technique (oil on panel), naturalistic approach (the depiction of movement, behavioral patterns, and multiple views), and subject matter (life studies of animals) produced highly prized artifacts.[14] Within a culture that treasured natural and man-made specimens, such sketches done ad vivum (from life) would have been valued as curiosities with documentary status, meriting preservation on panel.[15] Similarly, the early Renaissance Lombard studies of animals, which were prized possessions of the workshop, were drawn on a durable medium, such as vellum, and bound in books for protection.[16] Leonardo da Vinci emphasized the importance of preserving sketches done from life:

Figure 19
Jan Brueghel the Elder
and Peter Paul Rubens
(Flemish, 1577–1640),
*The Madonna and Child
in a Garland*, circa 1621.
Oil on panel. Madrid, Museo
Nacional del Prado, 1498.

For these are not to be erased but preserved with great care, because these forms and actions are so infinite in number that the memory is not capable of retaining them, wherefore keep your sketches as your aids and teachers.[17]

Thus, Brueghel's naturalistic oil sketches took on a mnemonic as well as a pedagogical function.

Although the illusionistic elements of color, movement, multiple views, and detail provide a resemblance to the real specimen, the effect on the viewer plays an important role. Evidently, Brueghel's precise descriptions of animals and flowers achieved their desired effect on collectors, such as Cardinal Borromeo, who described their ability to replace the actual specimens.[18] Brueghel's close study of the animals' true physical and behavioral qualities enhances the credibility of their representation. Although the level of resemblance depends on the mode and quality of the image, such associations involve not just an aesthetic judgment, but also an empirical process. Brueghel's approach to nature studies displays a systematic method based on careful observation and the various types of description cited above.

The Menagerie of the Archdukes Albert and Isabella

How was Brueghel able to describe animals, and in particular exotic species, so precisely in his *Entry of the Animals into Noah's Ark*? The menagerie in Brussels of his patrons the Infanta Isabella of Spain and her husband, Archduke Albert of Austria (hereafter referred to as "the Archdukes"), provided him with the necessary resources for such observation. In 1621 Brueghel wrote Cardinal Borromeo in Milan that he had studied the animals

in the menagerie for his *Madonna and Child in a Garland*, now in the Prado, Madrid [FIGURE 19].[19] Many of the same animals, such as the tortoises, rabbits, guinea pigs, and porcupine, appear in *The Entry of the Animals into Noah's Ark*, which Brueghel also produced while he was court painter to Albert and Isabella, from 1606 until the end of their reign, in 1621. Although the Archdukes were focusing on the war with the newly formed Dutch

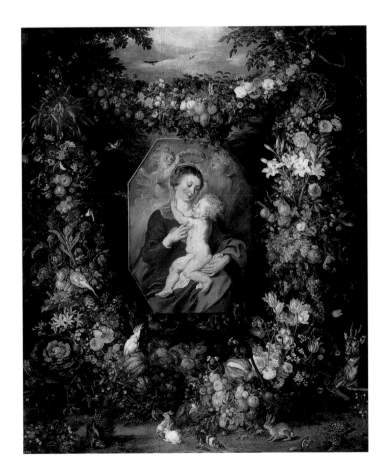

13

Republic until the Twelve Years' Truce of 1609, they managed to create a flourishing court culture, reminiscent of that of the Burgundian rulers in the fifteenth century. Their large art collection of predominantly Flemish paintings, their menagerie of exotic species, and their comprehensive library reflected their encyclopedic tastes.[20] Much attention has been paid to the Archdukes' patronage of the great court painters Peter Paul Rubens (1577–1640) and Brueghel, but less to their cultivation of other interests, such as natural history. Brueghel's extensive exposure to the Archdukes' menagerie over a lengthy period of time may have been the catalyst for his representation of a variety of species in an orderly manner.

The royal tradition of collecting animals in the Netherlands had its roots in the fifteenth century. From 1446 on, Philip the Good (1396–1467), ruler of the Netherlands and Duke of Burgundy, owned many animals in Brussels, including a lion, wolf, lynx, fox, ibex, tabby cat, wild boar, stags, zool hares, and deer.[21] He ordered the lion from Venice in 1461 and employed a keeper to care for it by the name of Lemoine. The menagerie also included monkeys, as a Colette de Noville was documented in 1462 as caring for them, as well as small birds, cared for by the surgeon Henri Bogaert. Through the marriage of Emperor Maximilian I of Austria (1459–1519) to Mary of Burgundy (1457–1482) in 1477, the Habsburgs inherited the Burgundian territories, including the Netherlands, as well as their collections. Maximilian I's son, Archduke Philip the Handsome of Austria (1478–1506), ruler of the Netherlands and Duke of Burgundy, continued to develop the menagerie in Ghent by acquiring camels, ostriches, and other exotic animals. Philip the Handsome's son, Emperor Charles V (1500–1558), who

often staged animal combats, acquired two lions and kept wild boar and birds in Ghent. After Charles V, a succession of Habsburg emperors and kings, such as Maximilian II, Rudolf II, and Philip II, established notable menageries. Rudolph II and his brother, the Archduke Albert, who received their upbringing at the Spanish court, may have been inspired by the collection of their uncle Philip II. On the grounds of the royal palace in Madrid the Spanish king had a rhinoceros pen, an aviary with exotic birds (including ostriches), and enclosures for elephants, lions, leopards, and camels.[22] Isabella, the daughter of King Philip II of Spain, and her husband, Albert, the son of Emperor Maximilian II and nephew of Philip II, continued this imperial Habsburg tradition of collecting animals.

Barely a year after their arrival in Brussels, the Archdukes made a concerted effort to create a menagerie on the grounds of their palace. In 1599 they remodeled the park to include enclosures for different animals.[23] They had a small boat installed in the fishpond, which contained a variety of fish as well as tortoises and crayfish. Perhaps Brueghel studied the tortoise for his painting there. Nearby, they built a new orangerie, which adjoined the pen housing the hares. The aviary, rabbit hutch, and cages with wild animals were placed near the vineyard, and the vegetable and fruit gardens were newly planted. One of the new grotto niches designed by the French engineer Salomon de Caus housed exotic birds.[24]

Numerous documents describe the menagerie, such as inventories listing the types of birds they owned: Indian hens, white and colored peacocks, grouse, ducks, pheasants, partridges, zool quails, nightingales, and canaries.[25] In 1605 Isabella received from her brother Philip III

in Spain two large crates with marmalades, sugared fruits, Indo-Portuguese objects, and exotic animals and birds, including three parrots, two macaws, and tiny lion tamarin monkeys.[26] In 1612 the Archdukes acquired nineteen parakeets and three marmots; in 1615 they purchased crows, a scarlet macaw, and a toucan (by 1621 there were three macaws in the menagerie); and in 1617 they bought dozens of canaries.[27] They also owned hares, squirrels, camels, and deer. The *falconnerie*, or hawk house, housed gyrfalcons, partridges, and the three royal eagles. A document of 1611 states that the falconer received 1,800 livres per year to maintain the hawk house; he also had to care for the greyhounds, six spaniels, and three horses. The inventories of 1619, published by Finot, mention the *feuillée*, the private enclosed garden of the Archdukes, which had various plants, a trout pond, and a large aviary with parrots, nightingales, and canaries.[28] They also had an aviary at their estate in Tervuren and a collection of herons in Boitsfort, their castle near Brussels where most of the ducal hunts had taken place since the time of the Dukes of Brabant (fourteenth century). We know that the Archdukes owned dromedaries, because four of them appeared in the Ommegank procession of May 31, 1615, together with an aviary mounted on a wagon.[29] The Ommegank took place every year in Brussels to commemorate the translation of the miraculous image of the Virgin Mary. Denis van Alsloot's painting *The Ommegank* of 1615 (Victoria and Albert Museum, London) depicts a float representing *The Triumph of Isabella* with a cage filled with diverse birds as well as dromedaries. Brueghel therefore could have easily referred to a live model for his camel.

The accounts of visitors to Brussels provide further evidence of the animals in the menagerie. Duke Ernst-Johann of Saxony visited Albert and Isabella in 1613 and described their park as filled with deer and birds. According to him, they had aviaries with parrots, Indian ravens (scarlet macaws), rare pheasants, wild and Indian pigeons, peacocks, Icelandic sparrow hawks, and large ducks. Pierre Bergeron and Jean Fontaine's account of their visit to the ducal palace in 1617 also mentions the aviaries and fishponds.[30] Isabella apparently had some favorite pets: a French courtier observed on July 16, 1621, that in her distress upon the news of Albert's death, she chased out her pet dogs, parrots, and guenon monkeys.[31] Indeed, numerous dogs, two monkeys, a cockatoo, and a parrot are depicted in a painting entitled *Dona Juana de Lunar and the Dogs of the Infanta Isabella*, leaving little doubt as to the veracity of the account [FIGURE 20].

Other paintings provide further evidence of the animals in the menagerie. The *Portrait of the Infanta Isabella Clara Eugenia* attributed to Alonso Sánchez Coello portrays the Archduchess and her dwarf Magdalena Ruiz with two specific types of monkeys: a golden lion tamarin, found in the rainforest of Brazil, and a cotton-head tamarin, both marmosets native to northern Columbia [FIGURE 21].[32] The artist must have based his accurate representations on direct observations, since the cotton-head tamarin does not appear in any of the encyclopedias nor in books of animal studies by other artists. Furthermore, Isabella received a few golden lion tamarins from her brother Philip III in 1605. Europeans had discovered these neotropical monkeys at the end of the fifteenth century, and Gesner included the lion tamarin in his *Historia Animalium*; however, his woodcut is quite schematic and pedestrian.[33] Fashionable ladies often carried these small,

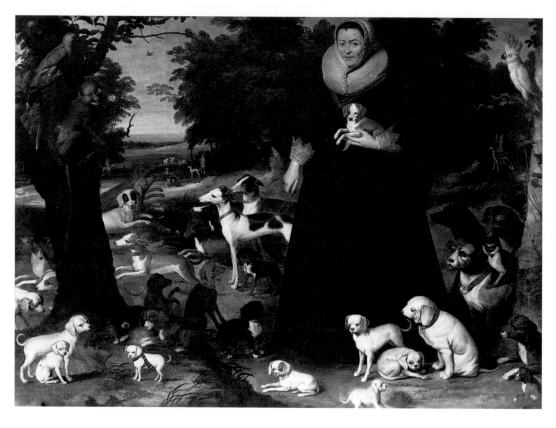

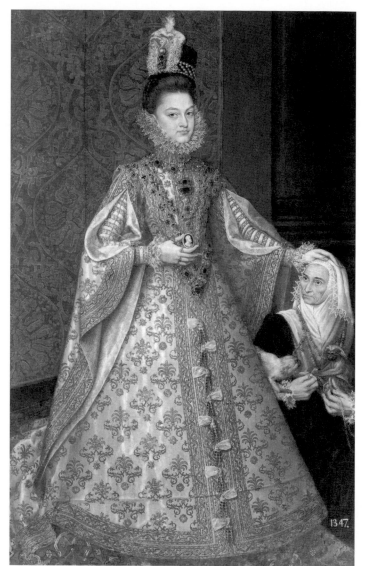

Figure 20

*Dona Juana de Lunar and the
Dogs of the Infanta Isabella*,
circa 1617. Oil on panel,
18.8 × 25.1 cm (7⅜ × 9⅞ in.).
Brussels, Musées Royaux
des Beaux-Arts, 6417.

Figure 21

Attributed to Alonso
Sánchez Coello (Spanish,
1531/32–1588), *Portrait of the
Infanta Isabella Clara Eugenia*,
1579. Oil on panel, 207 × 129
cm (81½ × 50¾ in.). Madrid,
Museo Nacional del Prado.

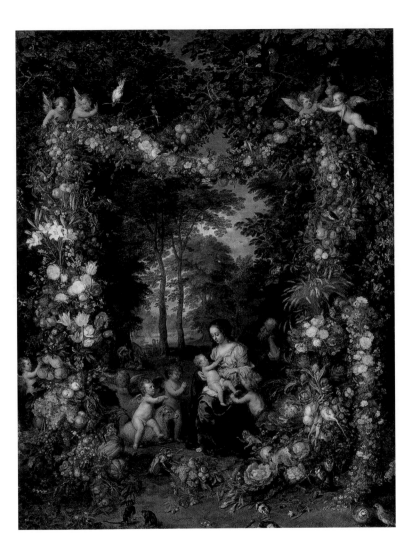

Figure 22

Jan Brueghel the Elder
and Pieter van Avont[?]
(Flemish, 1600–1652),
*The Madonna and Child
in a Garland*, circa 1620.
Oil on panel, 93.5 × 72 cm
(36¾ × 28⅜ in.). Munich,
Alte Pinakothek, 149. Photo:
Blaue Gnamm, Artothek.

domesticated monkeys on their sleeves. Brueghel also depicts the golden lion tamarin in his *Madonna and Child in a Garland* in Munich, together with a *Cercopithecus preussi*, a *Cebus apela*, a common marmoset from Brazil, and a variety of exotic birds, including a toucan [FIGURE 22].

The Archdukes in the Garden of Their Palace in Brussels by Jan Brueghel the Younger provides more visual evidence of the animals in the Brussels menagerie [FIGURE 23].[34] Albert and Isabella, with their courtiers, observe and feed a variety of ducks, an ostrich, a barnacle goose, peacocks, cranes, herons, and deer, all listed in the inventory. The different types of ducks include muscovies, shelducks, bustards, and mallards.[35] Along with others in a series by Jan the Elder depicting the Archdukes in the parks of their various estates, this painting functioned as a visual document of the regents' leisure activities.

Circa 1600: The Bounty of a Wondrous New World

The correlation between certain animals and birds from the menagerie and those in Brueghel's *Entry of the Animals into Noah's Ark*, garland paintings, and oil sketches implies that he conducted his natural observation there. Of the creatures mentioned in the documents describing the menagerie, Brueghel depicts peacocks, ducks, pheasants, hares, dromedaries, deer, parrots, macaws, herons, toucans, tortoises, pigeons, and lion tamarin monkeys. The stylized illustrations of peacocks, camels, monkeys, and parrots in the natural history catalogues of the time could not have provided him with such accurate representations, and certainly not coloration.

In addition to the Archdukes' menagerie, specific cultural circumstances enabled Brueghel to depict such an

17

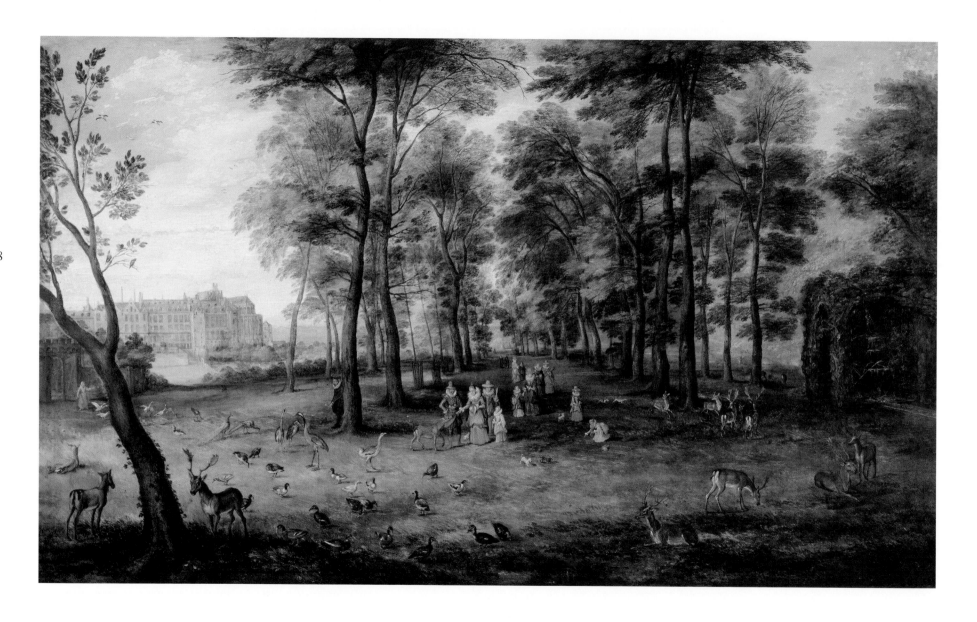

Figure 23

Jan Brueghel the Younger
(Flemish, 1601–1678), *The
Archdukes in the Garden of
Their Palace in Brussels*, 1621.
Oil on panel, 46.2 × 75 cm
(18¼ × 29½ in.). Antwerp,
Rubenshuis, RH S130.
Rubenshuis © Collectiebeleid.

Figure 24

Abel Grimmer (Flemish,
circa 1570–circa 1619) and
Hendrik van Balen (Flemish,
1575–1632), *View of the Port
of Antwerp*, 1600. Oil on panel,
37 × 44 cm (14⅝ × 17⅜ in.).
Antwerp, Koninklijk Museum
voor Schone Kunsten, 817.

abundance of species naturalistically. Although he was court painter to the Archdukes in Brussels, he received permission to reside and produce most of his work in his hometown of Antwerp, a relatively short distance from Brussels. In Antwerp, a major port that was flooded with precious goods from the New World, Brueghel would have come into contact with a variety of animals. Some of the species in *The Entry into Noah's Ark* [FIGURE 1] were common types native to northern Europe in the seventeenth century, and most of the exotic creatures were imported to Antwerp from North and South America, Africa, and India.[36] One of the most significant results of the discovery of these unfamiliar species was the natural history catalogue. A summary of the historical and cultural context within which Brueghel produced this painting will help to situate his approach to nature. The players in the following story belonged to five main strata of the time: the marketplace, court, university, church, and artist's studio. Beginning in the 1550s they shared a growing interest in nature, and in animals in particular. People began to explore the world around them in a more experiential manner and found that seeing led to knowing.

The burgeoning trade routes to the New World lay at the root of this increasing fondness for animals and natural specimens. The merchants and tradespeople were largely responsible for bringing new exotic species to the Old World.[37] The city of Antwerp in the Southern Netherlands had been the leading commercial center of western Europe since the fifteenth century because of its ideal location at the nexus of the major north–south and east–west trade routes [FIGURE 24]. The Austrian Habsburg family had governed the Netherlands since 1477. In 1516 the Habsburg Emperor Charles V became Charles I of Spain when his

maternal grandfather King Ferdinand II of Aragon died; he thus officially founded the Spanish branch of the Habsburg dynasty. The Southern Netherlands continued to be ruled by the Spaniards under the Archdukes Albert and Isabella (r. 1599–1621), whose trade with foreign lands was quite extensive. Isabella's father, the Habsburg King Philip II of Spain (1527–1598), brother of the Holy Roman Emperor Ferdinand I, held title to all of the Netherlands and had granted Albert and Isabella sovereignty of the Netherlands in 1599, thereby providing the region with some independence. When Philip II seized the Portuguese throne in 1580, he inherited its trading posts in India, the East Indies, and Brazil. It was only natural that Antwerp should reap the benefits of this trade, since it was superior to Lisbon as a distribution center for

Figures 25 and 26
Jan Brueghel the Elder,
*The Entry of the
Animals into Noah's Ark*
[details of Figure 1].

spices to northern and central Europe. The Netherlands also became directly involved in trade with North Africa in the early sixteenth century, when ships from Antwerp sailed to Morocco and Tangiers.[38]

The secession of the Northern Netherlands, or the Dutch Republic, in 1579 at the Union of Utrecht and the ensuing war with the Southern Netherlands (1579–1648) affected the South's trade with North Africa because Morocco became allied with the Dutch. As a result many Antwerp merchants established themselves in Lisbon to conduct trade indirectly with West and North Africa. The Dutch Republic's control after 1584 of the Schelde River, which connects Antwerp to the North Sea, had a detrimental impact on the South. Nevertheless, trade and commerce in Antwerp continued to help sustain the economy of the Southern Netherlands during the early 1600s due mainly to the export of luxury items. The Twelve Years' Truce of 1609 between the North and the South also contributed to the economic stabilization of the South.

The exploration of other continents in the sixteenth century was a catalyst for the interest in exotic species. Spain and Portugal, the leaders in early overseas explorations, were predominantly motivated by their quest for gold. As early as 1419 the Portuguese discovered Madeira; in 1439 they reached the Azores; and from 1456 to 1460 they colonized Cape Verdes.[39] Notable expeditions that followed Christopher Columbus's discovery of America in 1492 include Vasco da Gama's trip to India in 1498 and Ferdinand Magellan's exploration of the East Indies in 1521. Europeans began to witness the results of such voyages in the importation of exotic species. Portuguese ships arrived in Lisbon with a variety of birds and monkeys from the New World. King Philip II wrote to the young Infanta Isabella and her sister during his stay in Portugal from 1581 to 1583, mentioning ships arriving from India carrying delicacies and a variety of animals.[40] The Portuguese discovered birds of paradise, like the ones flying in Brueghel's painting, in New Guinea by around 1519 [FIGURE 25].[41] Magellan's crew brought back the first birds of paradise in 1521, and by 1600 explorers had discovered three different types of these birds. The turkey, which also appears in Brueghel's *Entry of the Animals into Noah's Ark*, was of American origin (Mexico and the Antilles) and was brought to Spain in the beginning of the sixteenth century by conquistadors and Jesuits [FIGURE 26].[42] Thus, Brueghel did not have to travel long distances to paint certain exotic animals ad vivum, when Brussels and Antwerp provided him with plenty of live specimens to study.

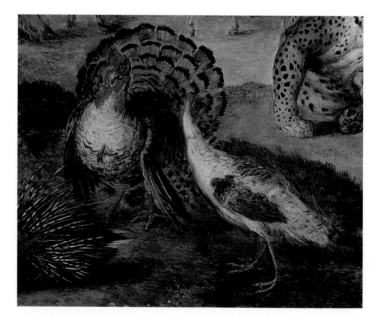

A Pictorial Catalogue of Species:
The Artist as Naturalist

European expeditions and the importation of animals had a major impact on natural historical inquiry, allowing aristocratic collectors and naturalists alike to have direct access to new material. The Spaniard Gonzalo Fernández de Oviedo's *Historia General y Natural de las Indias* of 1535, a chronicle of his voyage to America, included detailed zoological, botanical, and ethnographical descriptions.[43] In 1555 the French naturalist Pierre Belon published his observations of flora and fauna during his travels to Egypt and the Middle East, and in 1557 the French naturalist André Thevet introduced Europeans to the animals he discovered in Brazil in his publication of *Les Singularités de la France antarctique*. From 1571 to 1577 Philip II sent the Spanish naturalist Francisco Hernandez to Mexico, where he assembled about 1,200 natural history drawings. The Spanish missionary José d'Acosta studied American fauna in Peru in 1571 and published his findings in the *Histoire naturelle et morale des Indiens*.

This heightened fascination with natural wonders stimulated the intense desire of both collectors and naturalists to gather a large amount of information.[44] Universal intellectual curiosity was considered the hallmark of a gentleman, who acquired knowledge through the possession of a variety of man-made and natural objects. The increasing access to unusual natural specimens during the late sixteenth century contributed to the establishment of the first notable scientific collections. Important collectors of natural history throughout Europe include Ulisse Aldrovandi in Bologna, the apothecary and naturalist Ferrante Imperato in Naples [FIGURE 27], and the botanist Carolus Clusius in Leiden.[45] Their small museums exhibited stuffed animals and fish, precious minerals and stones, dried plants and herbs, fossils, and shells. While the collections of these naturalists tried to encompass all aspects of nature, the courtly *Wunderkammer* (cabinet of curiosities), such as that of Emperor Rudolf II, juxtaposed natural, scientific, and artistic wonders within the same framework.[46] The *Wunderkammer*, a microcosmic collection of the world, symbolized the power of its possessor, who held a central position in the cosmological order of the universe.[47]

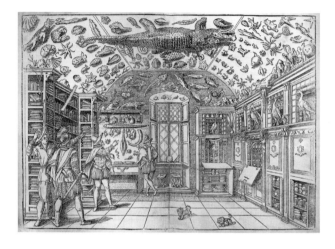

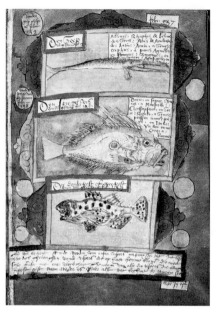

track of the fish they caught. Coenen discovered the most curious specimens at the markets and in turn displayed his findings there together with his illustrated book on fish [FIGURE 28]. His activities reveal how widespread the interest in animals was becoming and that it was not only an aristocratic and humanist hobby but also a mercantile occupation. The knowledge of nature began in the marketplace before it entered the sphere of *Wunderkammers* and menageries.[50] Naturalists such as Aldrovandi depended on fish vendors for their information about the various species.

In Brueghel's *Great Fish Market* of 1603, the inclusion of his family portrait illustrates the artist's encounter with the marketplace as a spectator [FIGURE 29].[51] He and his wife and children, situated prominently in the center foreground, observe the activity around them. Brueghel juxtaposes Italian topographical elements, such as the dome of Saint Peter's in the background, with the characteristic Flemish dress of the people in the foreground. His insertion of Saint Peter's and the Castel dell'Ovo in Naples into the landscape alludes to the knowledge of Italian culture that he acquired during his travels and recorded in his drawings.[52] His observance of classical Italian tradition sets him apart from the market folk around him yet counterbalances their firsthand knowledge of nature, specifically fish. Brueghel subtly contrasts the

Figure 27
The Museum of Ferrante Imperato, frontispiece from Ferrante Imperato, *Dell'historia naturale*, 1599. Los Angeles, Research Library, The Getty Research Institute, 84-B30646.

Figure 28
Adriaen Coenen (Dutch, 1514–1587), *Groot Visboeck* (Big Fish Book), 1577–79. Watercolor. The Hague, Koninklijke Bibliotheek, 78 E54, fol. 146r.

Such symbolism naturally held great appeal for rulers, who wished to assert their authority.

Our knowledge of sixteenth- and early seventeenth-century zoological collecting in the Netherlands is still rather scanty, but the collectors we know of formed a somewhat heterogeneous group of men and women representing a variety of professions, ranging from doctors and academics to princes and merchants.[48] For example, Adriaen Coenen (1514–1587), who produced manuscripts devoted to the study of fish, was a collector of humble background and limited education from the Dutch coastal town of Scheveningen, near The Hague.[49] Although he was a wholesaler in fish and an official beachcomber, his collecting and cataloguing activities are hardly surprising, since fishermen and merchants had to identify and keep

Figure 29
Jan Brueghel the Elder, *The Great Fish Market*, 1603. Oil on panel, 58.5 × 91.5 cm (23 × 36 in.). Munich, Alte Pinakothek. Photo: Blaue Gnamm, Artothek.

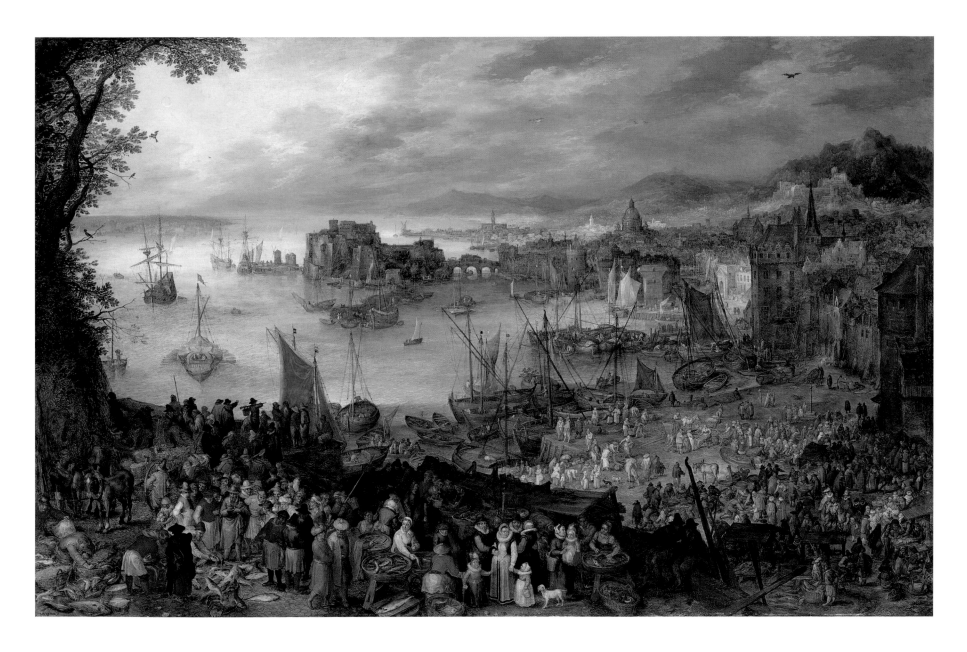

learned and privileged sphere that he inhabits with the mercantile world. As in his other paintings of port scenes with fishmongers preparing and selling their catch to merchants, he displays the fish carefully in the foreground, thereby allowing one to identify the various types. In this respect, these works function as catalogues of fish as well as of society, through their representation of people from different strata. Like the naturalist, the artist did not have to refer to books to learn about species because the accessible markets afforded him more tangible and concrete information.

The Culture of Cataloguing

The increased access to new animals resulted in the rise of related literature, which became useful to naturalists and artists. The first catalogues of natural history were published in the second half of the sixteenth century, spreading the knowledge of *naturalia*.[53] A brief overview of the most relevant publications that were produced before or during Brueghel's lifetime provides a sense of the rising interest in the presentation of information through the catalogue. The first printed catalogue of a scientific collection was that of the Veronese apothecary Francesco Calzolari, published in 1584. Ferrante Imperato's natural history collection in Naples was published soon after in 1599, and a catalogue of Ulisse Aldrovandi's natural history museum in Bologna appeared in the early seventeenth century. The extent to which this cataloguing drive was taken is revealed by Aldrovandi's catalogue of the visitors to his museum, which classifies them according to professional and social status and geographic origins.[54]

The publication of natural history encyclopedias, the first ones since Pliny the Elder's *Historia naturalis* (A.D. 77), was the most significant result of the encounter with new animals.[55] The invention of the printing press allowed Renaissance scholars to become more familiar with Pliny's ancient treatise, which formed the basis of their study of natural history. It was first printed in 1469, and by 1550, forty-six editions existed in various European languages, making it one of the most widely read books of the times. Pliny's encyclopedic work covers the planets, geography, man and his discoveries, animals, plants, minerals, medicine, the arts, and other topics. He was very knowledgeable about plants, but when it came to animals he often paraphrased Aristotle's three main treatises on natural history. Aristotle based his work on the direct observation of animals, birds, and fish, dividing the species into the "blood-bearing" (mostly vertebrates—mammals, birds, oviparous quadrupeds, and fish) and "bloodless" (mainly invertebrates—crustaceans, insects, and plant animals).[56] He created a model to systematize nature by studying the structure, development, and physiology of species. His process of classifying a living thing by its nature (how it functions as opposed to its superficial resemblances) required the examination of many specimens and the establishment of constant characteristics to facilitate constructive comparisons and groupings. This method dominated zoological classification until the nineteenth century. Pliny arranged animals by size, starting with the largest, the elephant, and tended to group species by geographical origins. Pliny, who did not pretend to be a scientist, described his process as one in which he compiles all knowledge and corrects it. In other words, the classification of animals was not his goal.[57]

DE PANTHERA SEV PARDALI.
PARDO, LEOPARDO.

A.
PANTHERA à Plinio & alijs scriptoribus Latinis dicta, quanquam originis Græcæ uocabulum, ut in progressu etiam dicemus, apud Græcos tamen non panthera, sed pardalis uel pordalis dicitur. Alius uero est Græcorum panther, masculini tantum generis: qui lupis adnumeratur: alij enim hunc ceruarium lupum esse uolunt, qui uulgò lynx nominatur;

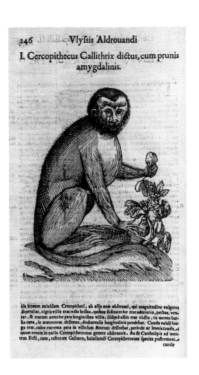

246 Vlyssis Aldrouandi

I. Cercopithecus Callithrix dictus, cum prunis amygdalinis.

eis iconem eiusdem Cercopitheci, ab alijs non obseruati, qui magnitudine vulgares superabat, nigra villis erat recta bestia, quibus suscus color erat admixtus, pectus, venter, & crurum anterior pars longioribus villis, illisq́ue albis erat obsita, ex mento barba cana, in mucronem definens, dodrantalis longitudinis pendebat. Cauda valdè longa erat, cuius extrema pars in villosum floccum desinebat, perinde ac leoni cauda, at quem notam in nullo Cercopithecorum genere obseruaui. An sit Cartholipis ad mentem Festi, cum, referente Gesnero, huiusmodi Cercopithecorum species postremam. cauda

The first sixteenth-century natural historian to systematically describe species using Pliny's and Aristotle's philosophical methodology as a basic starting point was Gesner, a Swiss physician and professor, in 1551. He was followed about fifty years later by Aldrovandi, professor of physics and natural history at the University of Bologna.[58] Their major contribution to the natural historical discourse was the application of an extensive system of description to each animal. Gesner placed all the species within four general categories—quadrupeds (four-footed animals), birds, fish, and serpents—and then described the creatures in alphabetical order and in terms of nomenclature, geographic origins, mode of living, behavior,

medicinal and nonmedicinal usage, nutritional value, philology, symbolism, mythology, and folklore. He separated the quadrupeds into groups of oviparous (egg-laying) and viviparous (bearing living young) species. Aldrovandi followed Gesner's model of providing all the known information about an animal, but did not order them alphabetically; rather he sorted them into homogeneous groups. For example, he grouped the horse together with analogous animals, such as the donkey and mule, and separated species into categories, such as birds with webbed feet and nocturnal birds. This form of classification depended on visual resemblance rather than the traditional linguistic ordering of an alphabetized catalogue.

For this reason the artistic representation of species played a crucial role in natural history of the time and contributed to the new methods of classification.[59] Gesner's and Aldrovandi's most significant improvement to the ancients' compendia was the addition of their own direct observations together with illustrations, some of which were drawn from life [FIGURES 30, 31]. Gesner employed the artists Hans Asper, Jean Thomas, and Lucas Schan, and Aldrovandi worked together with Cristoforo Coriolano, who made prints after drawings by Lorenzo Bennini, Cornelius Swint, and Jacopo Ligozzi. Gesner and Aldrovandi did not always rely on the information presented by the ancients, but tested it when possible by performing their own examinations of species. Knowledge based on experience rather than on traditional authorities was more strongly enforced by the Renaissance natural historians.

Despite Gesner's and Aldrovandi's emphasis on an experiential approach, they sometimes borrowed fish and bird illustrations from Guillaume Rondelet and Pierre

Belon, the respective experts on those species.[60] Unfortunately, Gesner could not afford to travel extensively, and he therefore had to depend on others for certain information about animals from distant places. Aldrovandi also replicated many of Gesner's images, because they represented firsthand observations. Because some of the secondhand illustrations by Aldrovandi and Gesner were based on other naturalists' observations, they were considered accurate and became in a sense emblems of the natural world that others continued to copy into the late seventeenth century.[61] The sixteenth-century naturalist Gonzalo Fernández de Oviedo, who was never swayed by secondhand information, rigorously applied an empirical and critical approach to his collection of data in the Dominican Republic. He explained that he reserved judgment on some aspects of certain species "because this particular detail I have neither seen nor heard."[62] Oviedo did not share the other naturalists' ambitious goals to catalogue every species known at the time. However, such an encyclopedic spirit is reflected in Brueghel's display of various animals in *The Entry of the Animals into Noah's Ark* [FIGURE 1].

Although Brueghel appears not to have referred to illustrations in the natural history catalogues for his work, as discussed earlier, he did adopt the methodology of Gesner's and Aldrovandi's encyclopedias. Like these naturalists, Brueghel grouped most of the species according to their basic categories of biological classification, in other words, according to the main groups of related species that resemble one another, such as birds or quadrupeds. He further classified most of them into subdivisions consisting of similar morphological and behavioral characteristics, such as those of waterfowl.[63] Aldrovandi's

methodology and rational ordering of birds must account for Brueghel's knowledge and ability to classify them in his painting. In 1613, when Brueghel painted *The Entry into Noah's Ark*, he would have been able to consult Aldrovandi's *Ornithologiae*, published between 1599 and 1603, but not his three books on quadrupeds, published posthumously between 1616 and 1637.[64] However, Brueghel could have derived some of his groupings of quadrupeds from Gesner, who published his encyclopedia between 1551 and 1558. Although Gesner ordered most of the animals within each book alphabetically, he did make some exceptions. Not surprisingly, he realized that domesticated cattle and wild oxen belonged together, as well as domesticated and wild goats. Aside from the basic distinction of quadrupeds as either oviparous or viviparous, his classification was limited to obvious visual connections. If Brueghel did not own copies of these encyclopedias, he certainly could have consulted the volumes owned by his close friend and frequent collaborator Peter Paul Rubens.[65]

The Classification of Species

Following Aldrovandi's example, Brueghel was the first artist to classify certain species in a painting. In Aldrovandi's encyclopedia and Brueghel's painting, animals are organized by physical resemblance and by basic biological characteristics, as opposed to alphabetically. The animal prints by the sixteenth-century Netherlandish artists Nicholas de Bruyn and Adriaen Collaert, which designated separate books for the categories of birds, fish, and quadrupeds, established a similar framework, which Brueghel and the beholder of his painting would

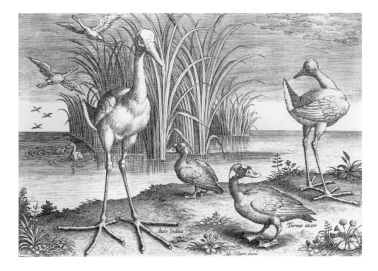

toward the ark at the prompting of a shepherd. Here, the artist achieved visually what the natural historians described only in words, for such information was provided in their written descriptions but not in their illustrations, which depict only schematic landscapes.

Just as Brueghel assembled the waterfowl in their habitat on the left side of the painting [FIGURE 33], Aldrovandi grouped birds with webbed feet, such as swans and geese, together with birds that live near the water but do not swim, such as storks and cranes, in Volume 3 of the *Ornithologiae* (1603). In Brueghel's painting this group is represented by the Eurasian bittern, gray heron, and white stork, all appropriately depicted in the water near the reeds.[67] The Eurasian bittern, found in the British Isles, Southeast Asia, and South Africa, has a camouflage pattern to escape detection in the reeds and grasses of its habitat. The gray heron, which was common in Europe, feeds while wading in shallow water. Brueghel also includes the common gallinule in the reeds, since it is a marsh bird native to Europe and Africa. Nearby are the common merganser from northern European regions, the domestic duck, and the northern lapwing, which breeds throughout most of Europe and lives in farmlands and grassy plains.

Brueghel represents a few varieties of parrots in the tree on the left side of the composition [FIGURE 34]. The multicolored Amazon parrot was native to the rain forests of the West Indies and to the region from Mexico to northern South America. Renaissance collectors appreciated its remarkable ability to mimic humans. The scarlet macaw from the region between Mexico and southern Brazil, the blue-and-gold macaw of Brazil, and the lovebirds of Africa and Madagascar are all perched nearby. The Portuguese imported these birds to Europe.

have known.[66] Unlike Brueghel's painting, these prints were inscribed with the names of the species [FIGURE 32]. Brueghel took the premise of the prints further by applying more descriptive elements, such as habitat and behavior, and by heightening the naturalistic appearance of the animals with color. Brueghel's visual catalogue of animals and birds functioned as a type of microencyclopedia, which had a more visceral effect than the achromatic prints and the naturalists' catalogues due to the more descriptive medium of painting.

Brueghel utilized the landscape as an ordering device to catalogue the different animals. He describes the characteristic behavior of the birds and animals in their appropriate and natural settings: dogs barking at ducks near the water, cats chasing birds in the tree, waterfowl near or in the stream, and monkeys climbing the tree. The bear, deer, and wolf emerge from the forest, their natural habitat, while the domesticated animals advance

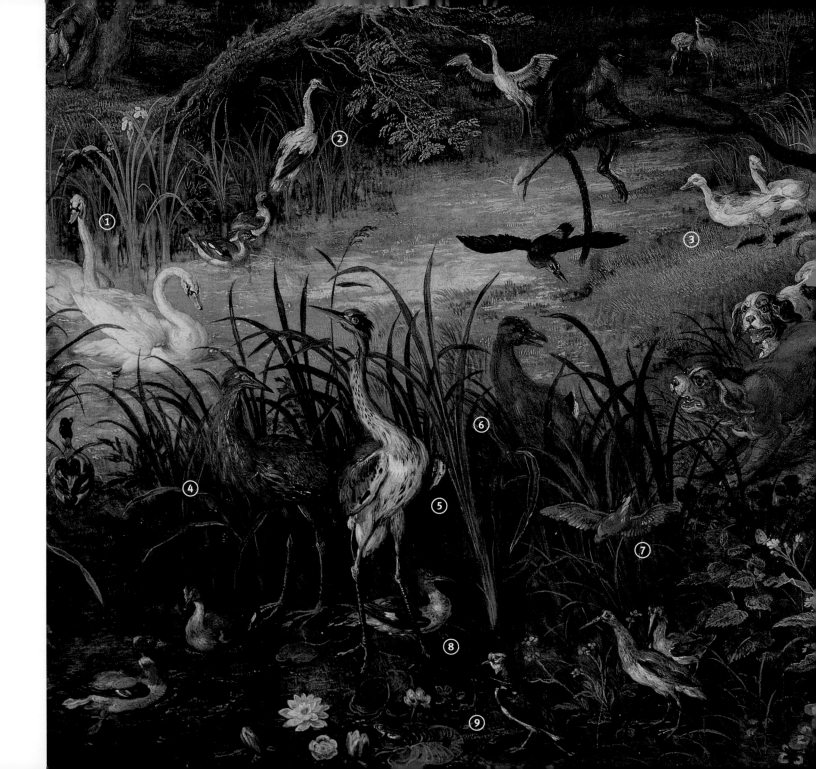

Figure 33
Jan Brueghel the Elder, *The Entry of the Animals into Noah's Ark* [detail of Figure 1 with identification of birds].

1 MUTE SWAN
 Cygnus olor

2 WHITE STORK
 Ciconia ciconia

3 DOMESTIC DUCK

4 EURASIAN BITTERN
 Botaurus stellaris

5 GRAY HERON
 Ardea cinerea

6 COMMON
 GALLINULE
 Gallinule chloropus

7 COMMON
 KINGFISHER
 Alcedo atthis

8 COMMON
 MERGANSER
 Mergus merganser

9 NORTHERN
 LAPWING
 Vanellus vanellus

Figure 34
Jan Brueghel the Elder, *The Entry of the Animals into Noah's Ark* [detail of Figure 1 with identification of birds].

1 SCARLET MACAW
 Ara macao

2 EUROPEAN
 GOLDFINCH
 Carduelis carduelis

3 LOVEBIRD SPECIES
 Agapornis sp.

4 AMAZON PARROT
 Amazona sp.

5 TIT SPECIES
 Parus sp.

6 BLUE AND GOLD
 MACAW
 Ara ararauna

7 COMMON PHEASANT
 Rhasianus colchicus

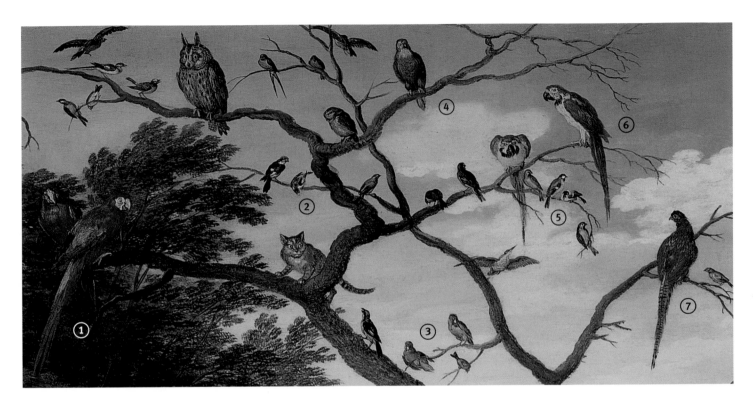

Aldrovandi, in Volume I of his *Ornithologiae* (1599), also grouped the parrots and macaws together in his chapter entitled "De Psittacus." Brueghel juxtaposed these exotic birds on the tree with common European birds, such as the goldfinch, pheasant, and owl.

The turkey, peacock, and ostrich on the right side of the painting [FIGURE 35] were classified by the ornithologist Pierre Belon in 1553 as birds that nest on the ground. In Aldrovandi's second volume of the *Ornithologiae* (1600), he classified the peacock and turkey as forest birds.[68] They all share two main traits: beautiful plumage, for which

they were prized, and the inability to fly. Brilliantly plumed birds embodied the beauty and exoticism of the New World. The Spaniards first imported the turkey from America around 1519 and soon thereafter it was bred throughout Europe. It was cherished as royal and rare meat and served at the wedding banquet of Charles IX and Elizabeth of Austria in 1570.[69] The Indian peacock, famous throughout the Old World, had an ornamental function in aristocratic collections. Although accustomed to hot and humid places, it can survive northern winters. The ostrich originally came from Africa and has large feathers that

Figure 35
Jan Brueghel the Elder, *The Entry of the Animals into Noah's Ark* [detail of Figure 1 with identification of birds].

1 DOMESTIC PIGEON

2 DOMESTIC TURKEY

3 INDIAN PEAFOWL
 Pavo cristatus

4 OSTRICH
 Struthio camelus

adorned hats and women's finery. Aldrovandi classified this bird on its own, since he felt that it had some features of quadrupeds, mainly due to its size. The birds of paradise shown flying above on the right side [see FIGURE 25] were also admired for their brightly colored plumage.

The small quadrupeds in the central foreground include the crested porcupine (found in Europe, Africa, and Asia), guinea pig (introduced into Europe after the discovery of America), chipmunk (from North America and central and eastern Asia), stoat mustela (native to North America, Eurasia, and North Africa), and mouse. TheNetherlandish artist Joris Hoefnagel (1542–1601) also depicted the guinea pig and porcupine together on the same folio (fol. 48) in his *Four Elements* manuscript (1575–80), and the squirrel and hare on the preceding folio [see FIGURE 39]. Gesner did not group these animals together, but Aldrovandi classified them as semiwild clawed animals in his posthumous publication of 1637, *De Quadrupedibus digitatis viviparis libri tres*.[70] Since it therefore seems unlikely that Brueghel knew of Aldrovandi's novel categorization, he probably presented them together based on their small size or Hoefnagel's manuscript. The European tortoises in the foreground are the only oviparous quadrupeds, or reptiles, in the painting. Their proximity to the waterfowl in the pond links them to the birds biologically, since they are also oviparous. The porcupine's prominent placement could have some meaning, since Gesner described it as the enemy of the snake and therefore as symbolic of the triumph of good over evil.[71]

Brueghel assembled quadrupeds, such as pigs, camels, antelopes, goats, rams, sheep, deer, and cattle, together on the right side of the composition. As has been mentioned, Gesner also placed different types of cattle together, such

as oxen, cows, and bulls, as well as domesticated and wild goats. Again, Brueghel's ordering of these creatures anticipated Aldrovandi's classification system, which grouped them as cloven-footed quadrupeds in his *Quadrupedum omnium bisulcorum historia*, published in 1621. However, Brueghel's configuration of these animals into a compact cluster also makes sense in rather rudimentary terms, since they were native to Europe (with the exception of the camel) and associated with their practical uses, predominantly consumption. Pastor Hermann Heinrich Frey, in his *Biblisch Tierbuch* (Biblical Animal Book), of 1595 classified these animals as clean species used for consumption. Frey grouped the Arabian camel or dromedary (common in North Africa, the Middle East, and India) with unclean animals used for work, such as horses and donkeys.

The lions and leopards—wild quadrupeds from Africa—appear prominently in the foreground, while the bear, bison, and wolf—wild European species—emerge from the far right background. Described by Gesner in his work as king of the beasts, the lion is pictured with the leopard; the bear (*urso*) and the fox (*vulpe*) appear together, but only because they follow each other alphabetically in Latin. They are all classified as wild clawed quadrupeds in Aldrovandi's posthumous publication of 1637. Brueghel may have grouped these animals together because of their association with hunting. Aldrovandi and Gesner describe all of the species in their catalogues in terms of their usefulness to humans, in particular hunting and nourishment. Similarly, Brueghel's empirical approach involved not only describing the animals physically but also representing them in terms of their function and significance within society.

Brueghel's Artistic Background:
The Tradition of Animal and Landscape Painting

Brueghel's interest in nature reflects the predominantly northern traditions of animal and landscape painting. An overview of the development of animal painting will illustrate how it resembles the descriptive and cataloguing approach of natural history and how artists' endeavors paralleled and contributed to the advances made in the field. For Brueghel, who was considered the leading landscapist of his time, the landscape also played a fundamental role in his representation of animals.

Brueghel's pictorial catalogue of an assortment of species can be traced back to medieval depictions of animals, which appeared within the format of books, namely religious illuminated manuscripts, bestiaries, and model books, or books of patterns used in a workshop. The borders of early Renaissance Flemish manuscript illuminations depict a variety of creatures and flowers with minute precision and brilliant color schemes [FIGURE 36]. Such images have an ornamental quality, but also served a devotional function as wondrous specimens of God's creation. Animals were also prevalent in northern Italian model books and pattern drawings by artists such as Giovanni de'Grassi and Antonio Pisanello.[72] The bestiary, a type of medieval natural history catalogue, remained more popular in the north and tended to present creatures in a moralizing context. Since they had a different purpose from workshop model books, they display less interest in achieving a naturalistic effect. Overall, medieval artists represented animals and nature in a predominantly religious context, not a scientific one. Their depictions, which were often quite stylized, had little or no empirical validity; rather, they had a mainly emblematic or heraldic significance.

The tradition of representing animals in an independent format was established in the early sixteenth century by Albrecht Dürer, who produced highly detailed watercolors of animals and plants.[73] Unlike the animals of symbolic significance that inhabit his religious paintings and prints, these descriptive animal portraits are some of the first empirical records of a direct encounter with a specimen. Dürer found it important to have firsthand experience and would travel long distances to observe

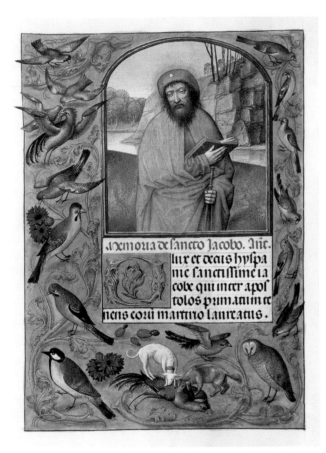

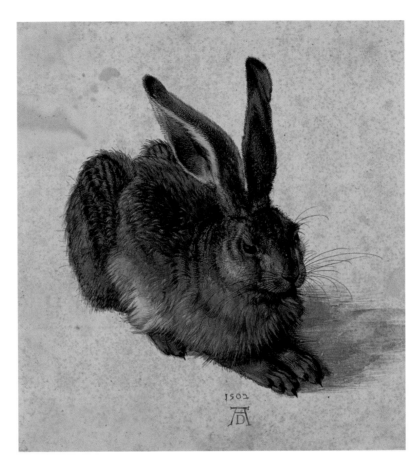

Figure 36
Workshop of the Master of
the First Prayer Book
of Maximilian, *Saint James
as a Pilgrim*, in the Spinola
Hours, Mechelen and
probably Ghent, circa 1510–20.
Illumination on vellum.
Los Angeles, J. Paul Getty
Museum, Ms. Ludwig IX 18,
83.ML.114, fol. 252v.

Figure 37
Albrecht Dürer (German,
1471–1528), *A Young Hare*,
1502. Watercolor and
gouache on paper,
25 × 23 cm (9⅞ × 9 in.).
Vienna, Albertina, 3073
(D49).

species, such as a beached whale in Zeeland, on the North Sea coast (unfortunately, he arrived too late). Many of his precise watercolors of individual creatures, such as *A Young Hare*, have an objective, veristic quality due to their precision and mastery of texture [FIGURE 37]. Brueghel was quite familiar with Dürer's depiction of animals; he imitated his watercolor *The Madonna with a Multitude of Animals* (1503), which he saw in Rudolf II's collection in Prague in 1604 [see FIGURE 47]. Brueghel would have also seen Dürer's *Hare*, since Rudolf acquired it together with other nature studies by the artist from the Imhoff collection in Nuremberg in 1588.[74]

Dürer's representations of animals play a pivotal role in Renaissance zoology, since they are the purest artistic

forms of nature study, or in natural historical terms, the first scientific step of visual description. For naturalists, description constituted the foundation of their inquiry. Aldrovandi maintained that "description yielded definition, definition order, and order knowledge."[75] As Gesner and Aldrovandi demonstrated through their use of illustrations, natural history depended on visual information provided by artists. For example, the collector Adriaen Coenen immediately took a fish he discovered at the market to an artist, who painted it for him.[76] This perception of nature based on direct observation was advanced not solely by scholars, who often favored textual knowledge, but also by artists, such as Dürer and Leonardo da Vinci.[77] Leonardo, who sought to elevate the status of the artist, emphasized the importance of the experiential approach:

> I know well that because I have not had a literary education there are some who will think in their arrogance that they are entitled to set me down as uncultured— the fools. . . . They do not see that my knowledge is gained rather from experience than from the words of others: from experience, which has been the master of all those who have written well.[78]

For Leonardo and artists like him, firsthand observation and description played a fundamental role in the accurate representation of nature.

Only in the sixteenth century, when the mechanical arts gained respect for their contributions to the scientific realm, did the two disciplines of art and science combine efforts to achieve significant developments based on the experiential approach.[79] Scientists, in particular natural historians, relied on graphic representation to make their claims and subsequently to compare their findings with others and correct them. For example, Aldrovandi and Gesner worked together with numerous painters, who illustrated their findings. The astronomer and physicist Galileo Galilei (1564–1642) paired up with the artist Ludovico Cigoli, who assisted him in the documentation of astronomical experiments. In addition, few sixteenth-century explorers embarked on long voyages without an artist aboard their ships.

The impact of natural history on art becomes evident in the first books of animal studies, which reverted in a sense to the early format of manuscripts and bestiaries, yet also adopted the precise technique of Dürer and the classification methods of the new encyclopedias. The depiction of animals in a more scientific and cataloguing context arose with Hans Bol's *Icones animalium avium*, a three-volume manuscript of quadrupeds, birds, and fish (circa 1573–77) and Joris Hoefnagel's *Four Elements* (1575–82), the first artistic works to categorize animals in a book format. Nature was no longer reserved for bestiaries accompanied by moralizing texts or the marginalia of manuscripts, but rather it became the main subject matter of books of animal paintings. In his books, the Flemish painter Hans Bol depicts only one species per folio, without a landscape backdrop and without inscriptions [FIGURE 38]. As a result, Bol's watercolors have a monumental quality that adheres to the tradition of Dürer's independent nature studies. However, Bol's organization of the species into three categories (including flying insects) signifies the first artistic attempt at classification. Bol also ordered the species by size, beginning with larger animals, such as lions, and ending with rodents and

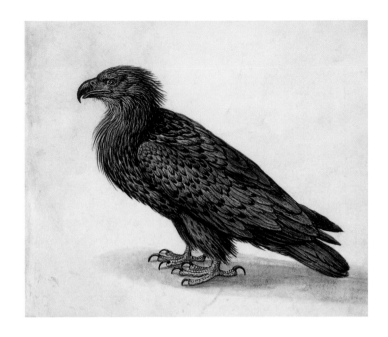

insects. His manuscript had an immense influence on other
Netherlandish artists, such as Joris Hoefnagel and Adriaen
Collaert, who copied him extensively.[80] Unlike Hoefnagel's
and Bol's books of nature studies, which were owned
by Rudolf II and therefore viewed only by an elite circle,
Collaert's two printed series of birds and fish, entitled
Avium vivae icones (1580) [FIGURE 32] and *Piscium vivae
icones* (1610), reached a wider audience.

Hoefnagel and Collaert took Bol's approach further
by adding inscriptions and landscapes and focusing more
on the behavior and grouping of similar types of animals,
sometimes on the same page [FIGURE 39]. They both
included zoological identifications as well as quotes from
the Bible and classical sources in Latin. The inclusion
of a variety of inscriptions provides these works with
an emblematic quality that reflects the type of information
presented in the Renaissance emblem books and natural
history encyclopedias; in fact, Hoefnagel acquired some
of his references to Erasmus's *Adages* from Gesner's
catalogue. Unlike Collaert and Hoefnagel, Brueghel did
not include any text; his images take the place of words.[81]

Hoefnagel's pansophic work, which combines natural
historical, classical, emblematic, and biblical references,
incorporates species into the categories of the four
elements of the cosmos: earth, water, air, and fire. His
manuscripts resemble the artistic format of the model
book yet also imitate the encyclopedia in their compre-
hensive presentation of nature. By including inscriptions,
Hoefnagel applied the natural historical categories of
identification, physical description, and symbolic meaning.
His reference to the texts as well as the illustrations
of Gesner's scientific work reveals the artist's attempt
to validate the accuracy of his representations.

35

AQVILA IN NVBIBVS.

AQVILA NON CAPTAT MVSCAS.

Hoefnagel's motivation to produce these books remains unclear, since he began them at the early stage of his career in Antwerp and then completed them in Munich while he was in the service of Duke Albrecht V of Bavaria in 1577 and his successor, Duke Wilhelm V, in 1579.[82] Hoefnagel presented the manuscripts to Rudolf II around 1590 when he entered imperial service. The artist was cited as an authority on the Latin names of fish by Rudolf II's *antiquarius* Daniel Fröschel in his 1607–11 catalogue of the emperor's collection.[83]

Aristocratic collectors played an important role in the development of such artistic catalogues of animals, since they not only commissioned works but also compiled their own books of animal studies by various specialists. They had the financial means to hire the best artists, unlike the less fortunate naturalists, who often lacked substantial funding and therefore had to settle for rather mediocre

talents. Rudolf II had the greatest collection of artist's books of animal studies, owning manuscripts by Bol, Hoefnagel, Jacques de Gheyn II, and Jacopo Ligozzi, as well as books that represented the animals in his collection. Brueghel would have seen these works during his visit to Prague in 1604. He certainly saw the manuscript of *The Four Elements*, since he imitated the eagle in his painting *Allegory of Air* [FIGURES 40, 41]. Rudolf II's *Museum* of 1605–10, in which few folios are inscribed, consists of two immense volumes of 179 oil paintings on vellum, predominantly by the court artists Dirck de Quade van Ravesteyn and Daniel Fröschel [FIGURE 42].[84] This impressive work represented the animals in Rudolf's menagerie and numerous specimens from his natural history cabinet.[85] Its execution in the precious medium of oil on vellum together with its monumental scale qualifies it as a pivotal and transitional work between the miniaturist watercolor tradition of nature imagery and easel paintings in oil of animals.

Rudolf's collection also included a few panel paintings of animals, most notably Hans Hoffmann's *Hare in the Forest* [FIGURE 43], which imitates Dürer's *Young Hare*.[86] Hoffmann, who was in the service of the emperor from 1585 on, copied Dürer's nature drawings extensively and transformed them into finished paintings. (Dürer's

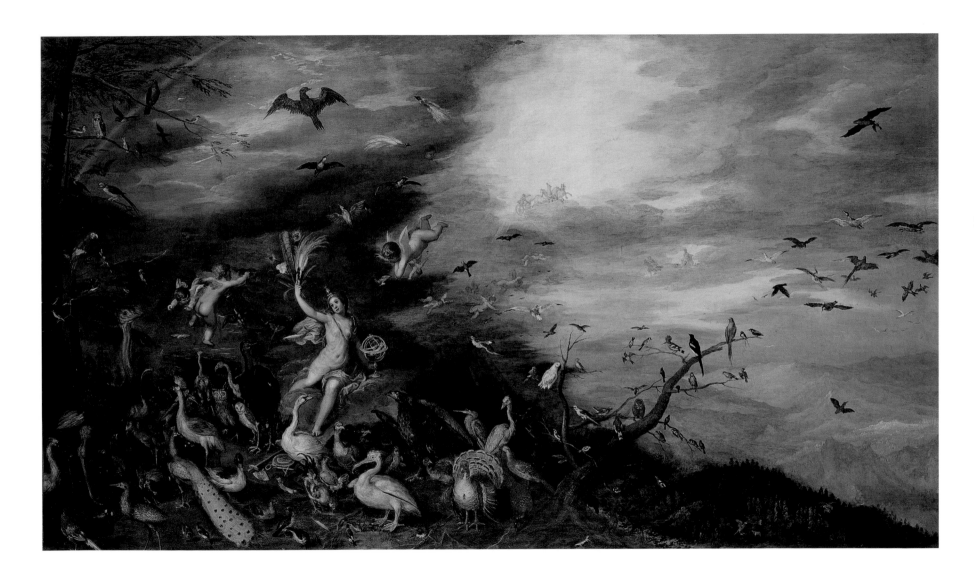

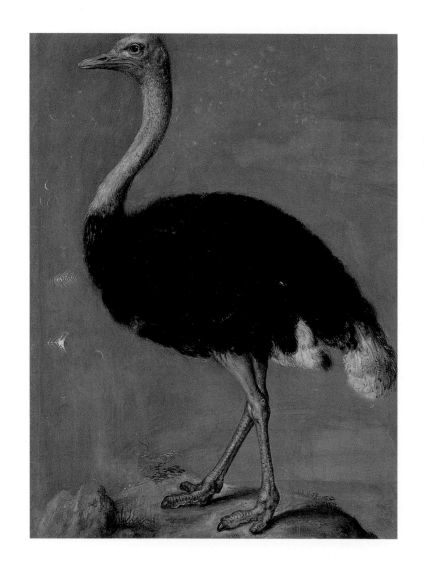

38

watercolors also influenced Hoefnagel, who included a copy of the *Hare* in his *Four Elements* manuscript [FIGURE 39]). Hoffmann, like Dürer, depicts the hare as the principal subject matter; however, he shows the animal eating a leaf and places it within its natural environment of the forest, surrounded by a frog, a bird, butterflies, and other small insects. He thereby alters the isolated, empirical quality of Dürer's watercolor on paper.[87] Nevertheless, by depicting the hare's habitat as well as its behavior, Hoffmann applies some of the descriptive categories employed by the natural historians and his fellow court artist Hoefnagel. This seminal work represents one of the first examples of the new genre of independent animal easel painting, which would become popular in the seventeenth century.

Where does one place Brueghel's easel oil paintings, particularly *The Entry into Noah's Ark*, within the tradition of animal painting outlined above? Dürer's intense concentration on an isolated image certainly remained unsurpassed. Indeed, such magnified studies have a greater sense of immediacy than Brueghel's complex, artificial juxtaposition of species, which did not function as an empirical record. Yet Brueghel's paradise landscape served a different purpose from Dürer's and Hoffmann's animal studies. Brueghel, who was not content to simply describe a single creature, embodied the encyclopedic attitudes of his time in his desire to describe an enormous variety of species. His composition multiplies the effect of an independent study from life by assembling and ordering numerous specimens. Each of the animals is so carefully rendered that together they have a powerful visceral effect on the viewer. For example, the guinea pigs in Brueghel's painting, which are significantly smaller

than the creatures in Dürer's watercolors, required fastidious attention and an accomplished miniaturist technique to achieve such veracity and detail. Furthermore, Brueghel, like Hoffmann, enlivened his representations by describing the animal's behavior and habitat.

Brueghel's miniaturist approach can be viewed within the tradition of the northern books of animal studies. Despite the different format of panel painting, Brueghel's *Entry of the Animals into Noah's Ark* and his other paradise landscapes have much in common with these books. They both display vivid coloration, a relatively small-scale format, and an attention to detail. The Netherlandish artist and biographer Karel van Mander's claim that Brueghel received his early training from his maternal grandmother, the miniaturist Mayeken Verhulst Bessemers, could explain his particular affinity for small-scale objects and fine details.[88] Unfortunately, we cannot compare their styles, since we do not know of any extant works by Bessemers. Jan was only one year old when his father died in 1569, so he could not have learned from him, and Jan's grandmother did, indeed, raise him and his brother Pieter II after the death of their mother in 1578. In addition to his lack of contact with his father, Jan did not have direct access to most of Pieter's paintings, which were already in private collections, such as that of Rudolf II. However, he and his brother somehow knew of their father's works, as they imitated them. It has therefore been assumed that their grandmother kept either copies or compositional drawings of Pieter's works in the studio. Jan did eventually see some of his father's paintings in the collection of Rudolf II in Prague in 1604.

Jan's miniaturist approach becomes particularly evident in comparisons of his works with his father's

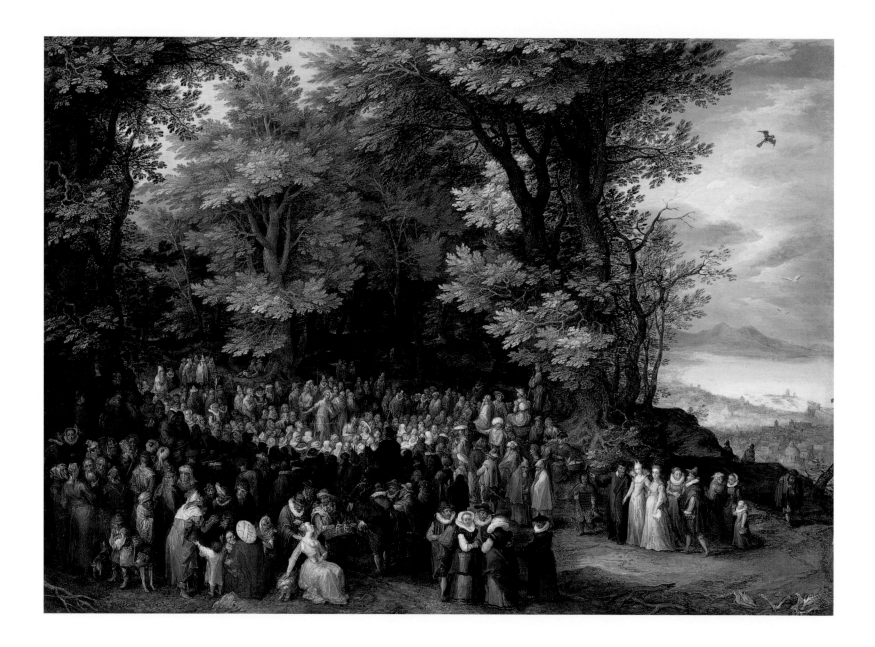

Figure 44

Jan Brueghel the Elder,
*Landscape with Saint
John the Baptist Preaching*, 1598.
Oil on copper, 26.7 × 36.8 cm
(10½ × 14½ in.). Los Angeles,
J. Paul Getty Museum,
84.PC.71.

Figure 45

Pieter Bruegel the Elder,
*Sermon of Saint John the
Baptist*, 1566. Oil on panel,
94.9 × 160.7 cm (37⅜ ×
63¼ in.). Budapest,
Szepmüveszeti Museum,
51 2829. Photo: Józsa Dénes.

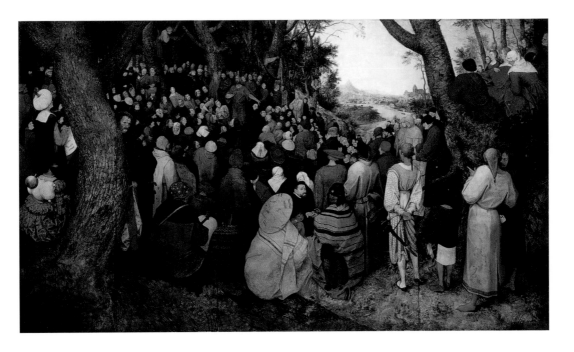

41

paintings of the same subjects. His *Landscape with Saint John the Baptist Preaching*, dated 1598, reveals his selective appropriation of motifs from Pieter's painting of the same subject, dated 1566 [FIGURES 44, 45]. Jan probably saw his father's painting in the collection of the Archdukes Albert and Isabella in Brussels, because their inventory of 1633–50, made after Isabella's death, includes this work.[89] He adopted certain figurative motifs, such as the gypsy with a child and the lady with a knapsack. However, Jan completely transformed the work by depicting a greater multitude of easily identifiable figures representing the various strata of society and by placing them within a lush forest that opens up onto a vista of mountains and the sea. The formation of figures into small clusters, each of which plays out its own narrative, already reveals Jan's tendency to compartmentalize elements. One group on the left listens to a fortune-teller, another discusses the wares of a vendor, and an elegant party dressed in Venetian attire enters from the right and observes the entire spectacle before them. Some of the figures in the foreground of Pieter's work, such as the gypsy and the *Landsknecht* (mercenary soldier), stand out; however, most of the others merge into an indistinguishable mass of spectators. Jan's painting has a dramatically different appearance and effect on the viewer because of the copper medium, tiny size, and intricacy of details. Pieter's technique, on the other hand, consists of looser brushwork and lacks the richness and luminosity of Jan's painting. The precision,

42

polished surface, and small scale of Jan's work lends it
a jewel-like quality that more closely resembles the minia-
ture paintings in medieval manuscripts and Renaissance
books of animal studies.

Brueghel's paintings differ from the earlier books of
animal studies discussed above in their format and their
placement of animals within a landscape setting. While
Hoefnagel usually depicts animals on a landscape band or
a tree branch, Brueghel, like Hoffmann, represents crea-
tures as an integral part of the environment. Brueghel's
landscape imagery was rooted in the tradition of describ-
ing nature established by his predecessors, most notably
Joachim Patinir, Herri met de Bles, Hieronymus Bosch,
and of course his father, Pieter Bruegel. Patinir, who,
like Pieter and Jan, worked in Antwerp, laid the founda-

tions for the construction of the "world landscape" that
others in the Netherlands would follow and develop.[90]
Disregarding spatial unity and using a high horizon line,
Patinir depicts the most distant elements in a landscape
from a bird's-eye view, while at the same time representing
the foreground landscape and figures at eye level [FIG-
URE 46]. He constructed imaginative landscapes using
a specific formula consisting of three sections: a brownish
foreground, a green middle ground, and a blue back-
ground. Jan was the first landscapist to improve upon this
format, by including a vanishing point. This illusionistic
device, which already appears in his early village and
forest landscapes, provides his paintings with a more con-
vincing sense of space than Patinir's compositions.
However, the traditional Antwerp landscapists' attention
to detail in these expansive landscapes was carried on
by Jan, who was praised by Cardinal Borromeo for
"wish[ing] with his brush to travel over all of nature,
because he painted... seas, mountains, grottos, subter-
ranean caves, and all these things, which are separated by
immense distances, he confined to a small space."[91]
This vast landscape format allowed Brueghel to display
an abundant assortment of natural elements.

Brueghel's imitation of Dürer's watercolor entitled
The Madonna with a Multitude of Animals, which incor-
porates both landscape and animal elements, illustrates
what sets him apart from his predecessors [FIGURES 47,
48].[92] He painted a version of approximately the same
size (34 × 26 cm) after the watercolor he saw in Rudolf
II's collection in Prague. It has therefore been suggested
that Rudolf might have commissioned it as a protective
and decorative cover for Dürer's original.[93] This image of

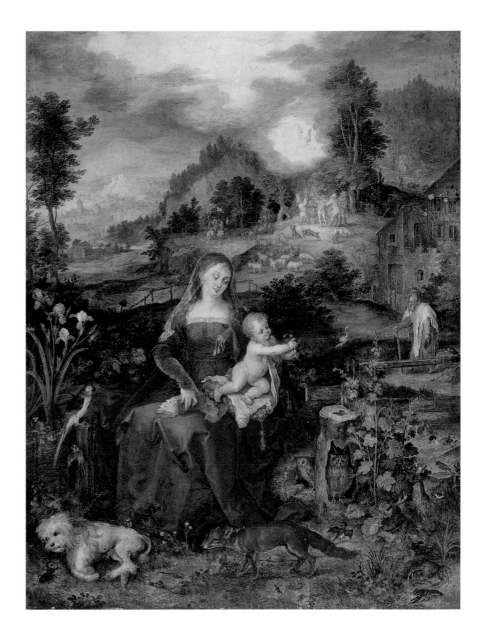

43

holy figures among a variety of creatures certainly would have appealed to Brueghel's sensibilities. The span of almost a century between the artists reveals his significant innovations. While the earlier drawing had a different function from the finished painting, it is interesting to see how Brueghel interpreted Dürer's design. He broke away from the early-sixteenth-century landscape format to create a more believable landscape that recedes into the far distance. While Dürer clearly delineates the background townscape directly above the Virgin's head, Brueghel faintly hints at a barely discernable port and town in pale blue and yellow hues. This part of the scene contrasts sharply with the brightly colored elements in the foreground of Brueghel's painting.

Jan's use of the landscape to catalogue animals differed from that of the earlier landscapists, who occasionally used their expansive format for the purpose of storytelling. They plotted the various stages of a biblical story, such as the Rest on the Flight into Egypt, throughout their backgrounds. However, Jan's father shared his tendency to present certain imagery in a cataloguing manner in a landscape or townscape. Pieter's encyclopedic paintings entitled *Netherlandish Proverbs* [FIGURE 49] and *Children's Games* resemble some of Jan's works in their use of space to arrange elements according to their functions and similitudes. In *Netherlandish Proverbs*, which Jan would have seen in Rudolf's collection, each space or building provides a proverb with an appropriate setting.[94] For example, the house on the left functions as the framework for proverbs, which make references to its spatial and social associations: "an old roof needs a lot of patching up"; "the roof has laths" (there are eavesdroppers). Pieter used specific spaces to organize the

proverbs or children's games much in the way that Jan used the landscape to define and classify species, e.g., waterfowl in a pond. Herein lies the main distinction between the two: Pieter did not apply the cataloguing approach to nature, but rather to society and culture of both the learned and popular spheres. As a humanist, he concerned himself with issues that focused on people and their place within society and nature. This does not imply that Jan did not share his father's interests, since Jan also catalogued the various segments of society in works such as *The Sermon of Saint John the Baptist* and his panoramic paintings of fish markets.

The encyclopedic methods employed by Pieter and Jan correspond to contemporary advances in scholarship: Pieter's in rhetoric and Jan's in natural history. The vocabulary of Jan's *Entry of the Animals into Noah's Ark* [FIGURE 1] resembles the taxonomic language of natural history catalogues. Pieter's works, on the other hand, reflect the popularity of chambers of rhetoric and literary clubs, as well as the satirical elements in the folkloric *ommegangen* (processions) in Antwerp and Brussels.[95] Both artists eliminated the written word and replaced it with the image; they did so effectively by organizing their information using spatial constructs, such as landscape elements and buildings.

The overriding significance of the text in its various manifestations linked the realms of art, science, and religion together in the sixteenth century. The cataloguing impulse of scholars, collectors, and natural historians paralleled the approach of the animal painters who ordered species in separate books. Brueghel's work shared not only the technique of animal specialists, such as Bol and Hoefnagel, but also their absorption of the scientific

44

Figure 49
Pieter Bruegel the Elder,
Netherlandish Proverbs, 1559.
Oil on panel, 117 × 163 cm
(46⅛ × 64⅛ in.). Berlin,
Staatliche Museen,
Gemäldegalerie, 1720.
Photo: Jörg P. Anders.

and religious language of the time. The reference to the Bible remains pervasive in Hoefnagel's inscriptions, Gesner's written descriptions, and Brueghel's choice of subject matter in his paradise landscape. Thus, reliance on textual authority continued to play an important role in all these works. In their common attempt to study animals in an empirical manner, artists and scientists found it impossible to separate their descriptions from the cultural attitudes of the time. Brueghel combined experiential and imitative methods to achieve a novel representation of animals that incorporated different systems of belief.

Brueghel and the Invention of the Paradise Landscape

The earlier paradise landscapes by Brueghel, which led to his masterful production of *The Entry of the Animals into Noah's Ark*, will provide insight into the evolution of his descriptive and cataloguing approach. The paradise landscape typically depicted a variety of species within a biblical context. Brueghel painted his first paradise landscape, *The Creation with Adam*, now in the Doria Pamphilj Gallery, Rome, in 1594, while he was in the service of Cardinal Borromeo in Rome [FIGURE 50]. The painting probably corresponds to Brueghel's *Creation of the World* in the collection of Cardinal Camillo Pamphilj (died 1666) in 1654.[96] However, we do not know whether the Pamphilj family originally owned *The Creation with Adam* in 1594.

This work was the first paradise landscape in which Brueghel "catalogued" animals. He depicts a variety of species in the foreground, ranging from common and domesticated types, such as sheep, dogs, cats, and rabbits, to wild and exotic creatures, including a lion, tiger, monkey, and peacock. Fish are displayed clearly in the stream on the left, and birds, such as parrots and owls, fly about

and perch in the trees. One's eye is eventually led to a clearing in the far right distance where God is shown breathing life into Adam. Certain animals, such as the leopard and monkey, are rather awkwardly depicted, while the domestic and farm animals are more naturalistically painted. The somewhat imprecise appearance of the exotic creatures suggests that Brueghel had not studied some of them from life. His later contact with various species in the Archdukes' menagerie would allow him to represent them more accurately. As his repertory of animals progressively increased, he produced variations on the theme of Adam and Eve.

Because the story of Creation provides the link between God and the natural world, Brueghel's choice of this subject to inaugurate his depiction of various animals was highly appropriate, as it alludes to the creation and naming of species in Genesis. In Genesis 2:18–19, Adam named the animals after they were created:

> Then the Lord God said, "It is not good that the man should be alone; I will make him a helper fit for him."

Figure 50
Jan Brueghel the Elder,
The Creation with Adam, 1594.
Oil on copper, 26.5 × 35 cm
(10½ × 13⅞ in.). Rome, Doria
Pamphilj Gallery, FC 274.

So out of the ground the Lord God formed every beast of the field and every bird of the air, and brought them to the man to see what he would call them; and whatever the man called every living creature, that was its name.

Renaissance authors felt that the names given to the creatures by Adam described their true essences, so the language of Adam became synonymous with the vocabulary of nature.[97] Adam spoke the language of God and therefore his pure choice of words gave the animals' names a divine quality. Scholars believed that Adam had true knowledge of the creatures in the Garden of Eden, and they explored the Book of Genesis to gain a better understanding of animals and nature in general.[98] Thus, the story of Creation was the perfect starting point for Brueghel's artistic exploration of nature.

Brueghel's allusion to the naming of the animals represents the first "scientific" step in his development of an artistic equivalent to the natural historical discourse. In both religion and natural history, naming or identification constituted one of the first steps toward understanding nature. In Gesner's encyclopedia each entry begins with the various names of an animal in every language, as well as their etymology. Edward Topsell, who promoted the study of nature as a guide to salvation in his *Historie of Foure-Footed Beastes*, refers to the wisdom of Adam in naming the animals:

> Their [i.e., the beasts] life and creation is Devine in respect of their maker, their naming divine, in respect that Adam out of the plenty of his own devine wisdome, gave them their several appellations, as it were

out of a Fountaine of prophesie, foreshewing the nature of every kind in one elegant & significant denomination, which to the great losse of all his children was taken away, lost, & confounded at Babel. When I affirm that the knowledg of Beasts is Devine, I do meane no other thing then the right and perfect description of their names, figures, and natures, and this is in the Creator himself most Devine, & therefore such as is the fountain, such are the streams yssuing from the same into the minds of men.[99]

Other scientists of the time, such as Francis Bacon, similarly encouraged man to turn directly to the Bible in studies of nature and to "recapture Adam's dominion over nature."[100]

Scholars legitimized the existence of humans and animals by acknowledging God as the Creator of all living beings. Pierre Belon voiced this reverence for God in his *Natural History of Birds* of 1555:

> Men of good birth endowed with the greatest courage, performing virtuous acts, and works worthy of their immortality, do not have difficulty lending themselves to the contemplation of the works of the Eternal (God) who created all things, knowing that the principal task of man is to praise, and with great admiration consider the excellence of his works, and not to cease magnifying the things that he knows surpass the capacity of his understanding, which the providence of this great architect wanted to have made for the utility of human life, and of other animals.[101]

Belon expressed his belief that one of the principal duties of a well-bred man entailed the study and admiration of God's creations in order to improve his understanding of the universe.

The story of the Ark played a critical role in the development of ideas about animals, particularly their origins and subsequent dispersal in various lands.[102] Naturalists underscored the epistemological significance of the event in their encyclopedias. For example, Topsell believed that God saved the animals to allow humans access to divine knowledge: "Surely, it was for that a man might gaine out of them much devine knowledge, such as is imprinted in them by nature, as a tipe or spark of that great wisdome whereby they were created.[103] The animals that Noah chose to save acquired a special significance. These "chosen ones" included the numerous species that naturalists were constantly discovering as a result of the ever-increasing explorations of the time.

Like Brueghel, the early natural historians were interested not only in the classification of zoological specimens but also in broader religious and cultural themes.[104] The categories employed to characterize animals reveal a pansophic approach: species came to be defined in terms of their literary, biblical, or morphological associations. Gesner felt that an animal could not be properly understood in isolation from the grand scheme of the universe; it had to be defined in terms of its network of associations. Sixteenth-century mythologies and emblem books, such as Andrea Alciati's *Emblematum liber* (1531) and Joachim Camerarius's *Emblemata* (1593–1604), provided naturalists with a large number of representations and a variety of literary and symbolic associations that contributed to the meaning of animals.

Thus, textual authority continued to play a fundamental role in the epistemological discourse of scholars and naturalists despite the new emphasis on an experiential approach during the sixteenth century.[105] At the center of this "bookish" culture was the archetypal text—the Bible. Naturalists imposed religious interpretations on natural history and, conversely, applied scientific criteria to a reading of the Bible. The depth of their analysis of the Word of God is particularly apparent in Aldrovandi's *Theatrum biblicum naturale*, a natural history of the biblical world. The overriding influence of the sacred text is evident in Brueghel's paradise landscapes, which represent God's creative power as described therein. His paintings of Adam and Eve and Noah's Ark highlight the abundance and variety of species created and preserved by the hand of God.

Scientists often referred to God's "book of nature" in their writings. Topsell thought of animals as words, which together formed a book written by God. He wrote in his *Historie of Foure-Footed Beastes*:

> That Chronicle which was made by God himselfe, every living beast being a word, every kind being a sentence, and all of them together a large history, containing admirable knowledge & learning, which was, which is, which shall continue, (if not for ever) yet to the world's end.[106]

For Galileo, the book of nature was "the true and real world, which made by God with his own hands, stands always open in front of us for the purpose of our learning."[107] This direct association between nature and the book exemplifies the sixteenth-century reconciliation of experiential and textual knowledge.[108] As Gesner wrote,

"Reason and experience are the two pillars of scientific research. Reason comes to us from God; experience depends on the will of man. Of the collaboration of the two, science is born."[109]

Brueghel and Borromeo: Art, Spirituality, and Nature

The religious strife between the Catholics and Protestants of about 1550–1650 contributed to the increasingly popular idea shared by naturalists and theologians that the study of nature brings one closer to God.[110] Both Protestants and Catholics utilized the positive allure of nature to benefit their respective causes and to attract followers. The Lutheran reformer Philip Melanchthon described in his *Doctrinae physicae elementa sive initia* (1552) how the study of nature is morally uplifting, since it reveals the divine beauty of creation. Many of the early naturalists, most notably Gesner, were Protestants influenced by Erasmus and Martin Luther, who viewed the study of nature as an essential part of their religion.[111] Since nature for Gesner was the creation and work of God, he believed that "the contemplation of things of the universe must lead us to a better understanding of God," an idea echoed in the writings of Topsell and Belon.[112] He tried to illustrate the purpose of creation and the ways man could benefit from it. Cardinal Paleotti, who supported Aldrovandi, saw nature and its representation in art as an educational instrument that could demonstrate the magnificence of God.[113] His friend and Brueghel's patron Cardinal Borromeo shared a similarly optimistic view of nature.

The Creation with Adam [FIGURE 50], as well as other works by Brueghel, reflects Cardinal Borromeo's spiritual outlook and keen interest in the natural world. During his lengthy stay with Borromeo in Rome and Milan from about 1592 to 1596, Brueghel painted numerous landscapes and still lifes for him. The Cardinal's patronage played an important role in Brueghel's artistic production; he commissioned Brueghel's first flower still life and his first Madonna in a Garland painting, both of which became popular genres in his oeuvre. Brueghel's encounter with Borromeo in Italy developed into a fruitful and long-lasting friendship.

Borromeo's philosophy provides the religious context within which Brueghel's paradise paintings were understood.[114] Borromeo based his religious views on the optimistic approach of Counter-Reformation spirituality, which advanced the notion that all things have a positive value and are worthy of contemplation. Borromeo began his career at the height of this optimistic phase of Italian spirituality, which spanned the years 1580 to 1600. He was particularly influenced by Filippo Neri, the founder of the Oratorian Order, who emphasized the virtuous significance of God's creation.[115] Like Neri, he perceived the extraordinary variety of living species as a reflection of divine power. Borromeo expressed this view in his numerous writings, some of which were published.

Brueghel's *Creation with Adam* corresponds with Borromeo's interest in the story of the Creation as discussed in his book *I Tre libri delli laudi divine*, published posthumously in 1632. Two main themes of the book, harmony and hierarchy in God's universe, are reflected in the peaceful cohabitation of animals and their hierarchical placement in Brueghel's painting. Borromeo encouraged the praise of God through the appreciation of his creations, in particular animals, to which he devoted a separate chapter.

Figure 51
Jan Brueghel the Elder, *Mountain Landscape with a Hermit*, 1597. Oil on copper, 26 × 36 cm (10¼ × 14¼ in.). Milan, Pinactoteca Ambrosiana.

Animals, therefore, must be our teachers, and they will teach us various things. And in order to bring forth and select one or two of the innumerable ones that there are, the ire of lions, the cruelty of tigers, the poisons of snakes, do they not perhaps allow us to see through very vivid examples how terrible and formidable divine ire can be? Looking then with attentive study at animals' construction and formation, and at their parts, and members, and characters, can it not be said how excellently divine wisdom has demonstrated the value of its great works?[116]

Borromeo shared Brueghel's interest in an animal's appearance and anatomy, and he needed to understand the essential character of a creature. In *The Creation of Adam*, Brueghel, indeed, depicts certain distinctive traits of animals, such as the "ire of lions" described by Borromeo.

Brueghel received praise from the Cardinal for his remarkable imitation of nature and ability to surpass reality. Because Borromeo believed that religious inspiration and devotion could be achieved through the contemplation of nature or works depicting nature, Brueghel's landscapes played a special role in his spiritual life by replacing his habitual outdoor prayer, which became almost impossible in Rome.[117] He was therefore inclined to collect and commission paintings of hermit saints, such as Brueghel's *Landscape with a Hermit Reading and Ruins* dated 1595 and *Mountain Landscape with a Hermit* of 1597, both based on engravings by Jan and Raphael Sadeler [FIGURE 51]. These paintings eliminated the prints' traditional iconography, such as Saint Anthony's demonic and carnal temptations, and instead emphasize the significance that solitude and the contemplation of the natural world had for Borromeo.[118] Together with pure landscapes, they supplanted the actual experience of nature for Borromeo.

The assemblage of animals in *The Creation with Adam* and later paradise landscapes would have appealed to the Cardinal much as Brueghel's paintings representing flowers from different seasons fascinated him. Brueghel responded to the Cardinal's appreciation of his protean talent by painting his first flower still life for him in 1606 [FIGURE 5]. Like the landscapes, this flower painting replaced the actual specimens for Borromeo.[119] The additive composition and painstaking attention to detail have much in common with Brueghel's paradise landscapes. In both types of paintings, he flaunts his ability to depict both faithfully and precisely a bountiful assortment of natural elements. In a letter to Borromeo describing this magnificent painting of a flower bouquet, Brueghel states, "In this picture I have accomplished all of which I am

51

capable. I do not believe that so many rare and varied flowers have ever been painted, and with such diligence."[120] Indeed, he also wrote that he had traveled to Brussels to draw from life certain flowers that were not available in Antwerp.[121] One would assume that by Brussels, he meant the palace gardens of Albert and Isabella.

Of the 172 paintings in Borromeo's collection, roughly one quarter represents landscapes and still lifes, mainly by Brueghel. The landscapes complemented the traditional religious history paintings and enabled Borromeo to achieve his goal of creating a comprehensive teaching collection for students in his art academy. The Pinacoteca Ambrosiana, the museum he established in Milan between 1607 and 1618, was encyclopedic in the scope of its works, including history paintings, landscapes, portraits, works on crystal, miniatures, drawings, and copies of well-known works. The Cardinal's Christian optimism is reflected in the subject matter of the works, which have hardly any pessimistic themes and typically depict the Adoration, Holy Family, saints, landscapes, and flower still lifes. Brueghel's choice of subjects corresponded particularly well with Borromeo's philosophy, since he mainly painted works with optimistic themes, such as *The Entry into Noah's Ark* [FIGURE 1]. He produced paintings of the Creation rather than the Expulsion of Adam and Eve from Paradise.

Although the nature of Borromeo's activities and beliefs probably had some influence on Brueghel, the artist's miniaturist technique and predilection for depicting nature were already inherent in his approach as the landscapes that predate his time in Italy demonstrate.[122] The small size of *The Creation with Adam* appealed to the Cardinal's spiritual and scientific appreciation of natural minutiae. Borromeo revealed his delight in the invention of the microscope, which enabled him to study small wonders: "In [looking through] these I have enjoyed making the acquaintance of just as many very distinct, very small little animals as exist."[123] Brueghel's gift to Borromeo of a small painting on parchment and copper, *Mouse with Rosebuds and Insects*, responds to this appreciation of tiny species. The artist's description of tiny species together with the scientist's invention of optical devices enhanced Borromeo's admiration of the wonders of God's universe. Brueghel and Borromeo not only shared an interest in the natural world but also an optimistic philosophy that advocated the celebration of God's earthly creations.

Ordering Nature: The Four Elements

Brueghel's next major painting of animals within a paradise landscape after *The Creation with Adam* was the *Allegory of the Elements*, painted in 1604 [FIGURE 52]. That same year he visited the court of Emperor Rudolf II in Prague, for whom he may have produced this work. Thus, his travels took him from the ecclesiastical world of Rome and Milan to the imperial one of Prague. This new encounter was quite different from the one he had while in Italy. Although Borromeo had been amassing an impressive book and art collection while Brueghel lived with him, his endeavors did not even come close to the unsurpassed acquisitions of Rudolf II.

In the *Allegory of the Elements* Brueghel orders nature for the first time. He groups the elements within the painting in the following manner: water is represented by fish and shells in the lower left; air by birds in the upper left; and earth by vegetation and animals on the right side

Figure 52
Jan Brueghel the Elder and
Hendrik van Balen (Flemish,
1575–1632), *Allegory
of the Elements*, 1604.
Oil on copper, 42 × 71 cm
(16½ × 28 in.). Vienna,
Kunsthistorisches Museum,
815.

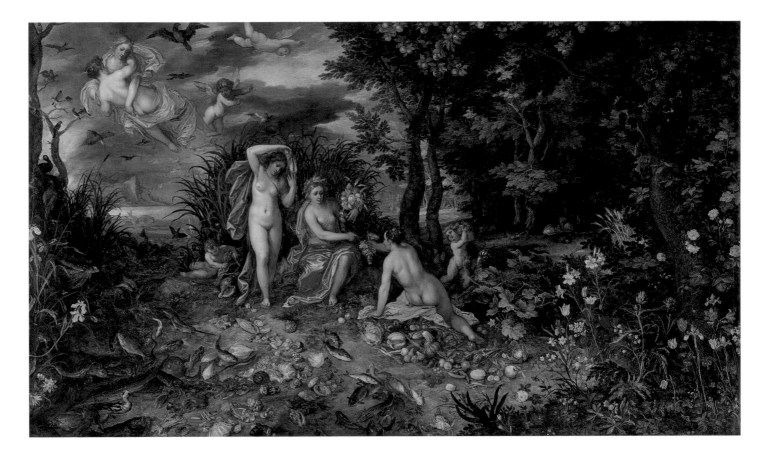

of the composition. Brueghel divided the composition into two sections, consisting of a wooded landscape on the right and a stream leading to a seascape in the background. This division is enforced by the still life of flowers and vegetables on the right, which counterbalances the colorful array of seashells and fish on the left. The mammals, such as the lions, are outnumbered by the fish and birds and only receive minimal attention in the background.

Interestingly, Brueghel does not depict any symbols of fire, such as the salamander and torch traditionally held by the deity, in this case Vesta. The five female figures, painted by Hendrik van Balen, with whom he often collaborated, represent the elements. Ceres, who symbolizes agriculture and fruitfulness, sits in the center holding a cornucopia, surrounded by personifications of water, probably Amphritite, and of earth, Flora. The flying figures

54

are most likely Juno (air) and Vesta (fire), whose attributes are clearly depicted in the later version of this subject in the Prado, Madrid (circa 1615).[124]

The Four Elements fits thematically within Brueghel's chronology of paradise landscapes and the story of Creation, since, together with the planets, the elements completed the universe created by God. In Sebastian Münster's popular encyclopedia of general knowledge entitled *Cosmographia* (1598), the Creation is represented by a spatial hierarchy of the four elements [FIGURE 53].[125] They are depicted in layers beginning with water as a seascape with fish, earth as a landscape with animals, air as the sky with birds, and fire as flames.

In the painting the *Allegory of the Elements*, Brueghel took the next step in the scientific process described by Aldrovandi as ordering. In Aldrovandi's taxonomic methodology, the initial procedures of description and naming led to the ordering of species. The four elements played a significant role in natural historical inquiry at the time because they represented the four natural categories of the cosmos. Aristotle and later Pliny the Elder, in his *Historia naturalis*, had arranged the world according to the four elements, which became a popular ordering device used by collectors, naturalists, scholars, and artists in the seventeenth century.[126] *Wunderkammer* objects, which represented the universe in a microcosmic manner, were often organized according to the four elements. For example, Ferrante Imperato's collection of natural history in Naples, which Brueghel may have visited during his travels in Italy, placed objects and species into these categories.[127] In Imperato's catalogue of his collection, published in 1599, the frontispiece depicts his museum with a variety of cabinets and an incredible display of birds, sea creatures, and shells [FIGURE 27]. Brueghel's paintings have a similar purpose to that of encyclopedic collections in their establishment of a link between the *mundus sensibilis* and the *mundus intelligibilis*. His approach to describing and cataloguing nature in art resembles the distinction the natural historian had begun to make between perceptual experience and theoretical knowledge. Both recognized the necessity to observe nature firsthand and situate it within an appropriate framework.

The collection of Emperor Rudolf II most likely provided Brueghel with natural and artistic resources that helped him develop his contextualization of animals. Rudolf's encyclopedic collection was ordered according to the categories of *naturalia* (natural specimens), *artificialia* (man-made objects, including many works of art), and *scientifica* (scientific instruments).[128] It was also an appropriate place for Brueghel to visit, since Rudolf owned

CORNVTÃ BESTIAM NE PETITO.
Dat Deus omne bonum sed non per cornua Taurum.

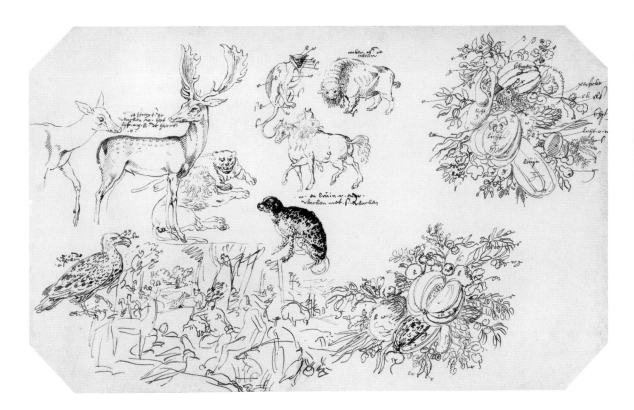

numerous paintings by his father Pieter Bruegel the Elder, most of which are now in the Kunsthistorisches Museum, Vienna.[129] Brueghel also encountered an array of exotic species at the imperial court, since Rudolf had an impressive menagerie, notable for its large collection of birds.

According to the inventory of paintings inherited by Albert and Isabella from Rudolf II in 1615, the emperor owned Jan Brueghel's *Ceres with the Four Elements*; this may be the painting now in Vienna.[130] It therefore seems more than coincidental that Brueghel painted the *Allegory of the Elements* in Vienna, the same year as his trip

to Prague, in 1604. Brueghel saw works in Prague that appealed to his particular aesthetic and probably influenced his painting of the Four Elements, most notably Joris Hoefnagel's *Four Elements* manuscript. Besides his imitation of Hoefnagel's flying eagle in the *Allegory of Air*, Brueghel also made a drawing after some of the animals and the fruit and vegetable garlands in *The Four Elements* [FIGURES 54, 55].[131] Rudolf also owned Giuseppe Arcimboldo's paintings of composite heads with animals representing the elements, and the antechamber of his *Kunstkammer* was decorated with images of the Four

56

Elements and Twelve Months.[132] The elements had a particular imperial significance due to the belief that the ruler, as possessor of the wonders of the universe, had a central position within the cosmos. Access to the coveted possessions in Rudolf's curiosity cabinet was apparently limited to the few initiates who knew how to use it, since many of the objects were stored in marked cupboards. Similarly, Brueghel's paradise landscapes may have had particular appeal for those who recognized his ordering of animals.

Brueghel's later renditions of the Four Elements theme, in which he devotes a separate painting to each element, reveal a systematic move toward the representation of animals based on the organization of Hoefnagel's manuscript. Brueghel translated the ordering device of Hoefnagel's four books into the format of four paintings. Other than the example of fire—which depicts alchemical devices and gold and silver objects—the allegories are quite straightforward, since they usually represent one type of species, for instance, birds in the *Allegory of Air*. Cardinal Borromeo commissioned one of Brueghel's first serial productions of the Four Elements, beginning with the *Allegory of Fire*, dated 1608.[133] This set, now split between the Ambrosiana and the Louvre, also includes the *Allegory of Water* of 1614, the *Allegory of Earth* of about 1618, and the *Allegory of Air* of 1621.[134]

The theme of the Four Elements was evidently of importance to Borromeo, since it permeates his writings. His *Parallela cosmographica de sede et apparitionibus daemonum* attests to his deep interest in the comprehensive and cosmographical organization of nature.[135] This treatise, which deals with cosmography and demons, includes chapters on the various elements and bodily humors. In *Le Laudi* he also includes a large section devoted to

the four elements and the animal world, which demonstrates his propensity to order the cosmos. Borromeo viewed the contrasts of nature, such as fire (hell) and earth (paradise), as complementary elements that together create an orderly universe.[136] He believed that the enormous variety of species required a system of order to demonstrate the virtue and science of their formation and organization.

Such an orderly representation of a copious number of species is reflected in Brueghel's allegorical paintings of the elements. For example, in the *Allegory of Water* of about 1614, Brueghel carefully assembles a variety of fish, waterfowl, and seashells [FIGURE 56]. He apparently attached a list of the creatures he studied from life to the back of the painting.[137] Different species, such as the squid, eel, blowfish, manta ray, and various types of crabs, are displayed in a manner that makes them easily identifiable. He depicts many of the creatures, such as the dolphin, in profile, and others, such as the crab, ventrally in the manner of the naturalists. The waterfowl in the painting include a gallinule, gray heron, spoonbill, pelican, and a variety of ducks. The flying fish in the sky, which also appears in the *Allegory of the Elements* of 1604 as well as in Rudolf's *Museum*, Giorgio Liberale's fish book (1563–79), and Gesner's and Aldrovandi's encyclopedias, is the only species that Brueghel represents in a somewhat impossible manner. While such a fish can, indeed, glide a few feet above water, Brueghel exaggerates its flying abilities, which he probably never witnessed.[138] Since Rudolf owned six of them, Brueghel might have seen this fish in Prague.[139] Brueghel also includes other aquatic species besides fish and birds, such as the seals in the left background and a salamander and frogs on the right.

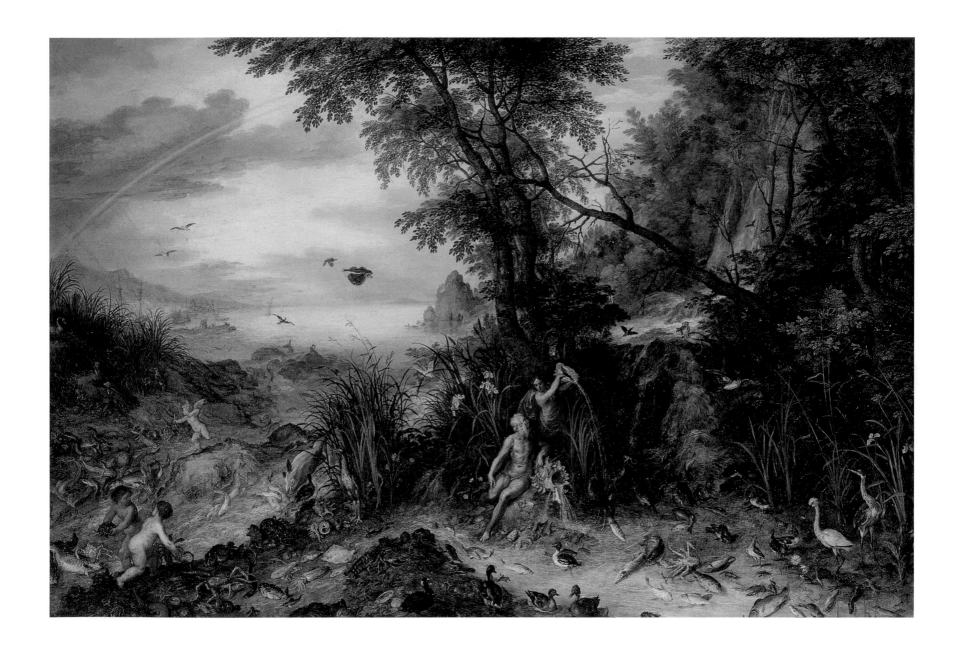

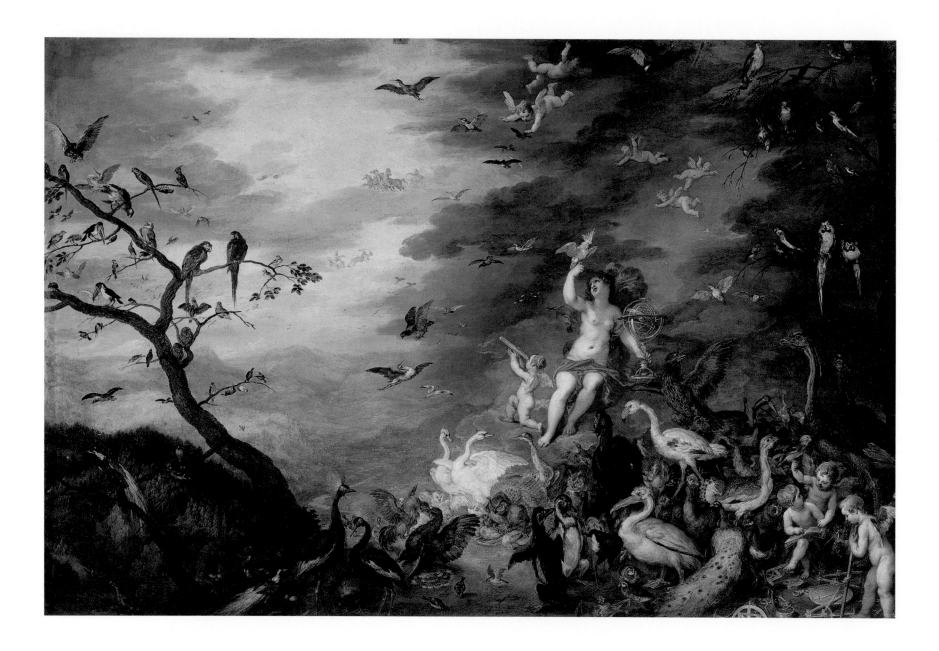

Borromeo emphasizes the encyclopedic nature of the painting in his *Musaeum*:

> Thus in the representation of the element of water, he has introduced so many and such varied kinds of fish as to make one believe him no less skilled at fishing than at painting. And there he has collected and disposed in beautiful display every sort of those freaks of nature and refuse of the sea that are the seashells.[140]

In a letter dated 1613, Brueghel mentions Borromeo's commission of other paintings of air and water in which he hopes to assemble as many diverse examples of nature as possible and paint them with the greatest accuracy.[141] Both Brueghel and Borromeo discuss the artist's endeavors in terms of a collector's enterprise: Brueghel's assemblage of a variety of species in a single painting resembles the comprehensive display of objects in art and natural history collections.

The last painting in the set for Borromeo, the *Allegory of Air* [FIGURE 57], now in the Louvre, made the greatest impression on the Cardinal:

> The air, which is seen as a plane of light, is encircled by every sort of pleasant things. If one then compares this with the other paintings, one is induced to believe that, being this his last, its author wished to use in it all his art and care.[142]

Brueghel, indeed, created a divine landscape of light, or a "skyscape," swarming with birds, putti, and mythological gods on chariots. The sky dominates more than half of the composition, as in the earlier Doria Pamphilj version [FIGURE 41]. Brueghel's vibrant representation of a multitude of birds recalls Borromeo's theatrical description of the element of air in his *Le Laudi*: "In the sky Nature wants to fabricate a triumphal arch in which one can see beautiful objects and diverse representations done with great skill, creating a solemn and pompous show of colors."[143] Borromeo possibly had Brueghel's painting in mind when he wrote this mature work, which was published posthumously in 1632. Brueghel depicts the birds as if they were on the highest point of a mountain, with the allegorical figure rising upward and forming the peak of the composition. In both versions of the painting, Juno holds an astrolobe, and the putto nearby looks through a telescope. Brueghel also displays instruments of measurement, such as the compass and sundial, in the foreground. These man-made devices together with natural specimens provided the necessary tools to study the universe. Brueghel's scientific interpretation of the element of air, which does not have an artistic precedent, underscores his empirical approach to nature.

With his paradise landscapes, Brueghel took his contextualization of animals to a new level by incorporating traditional artistic, religious, and scientific systems of ordering the universe. He transformed the print and book format of his predecessors and contemporaries into vivid paintings that redefined the standard notion of the catalogue. His pictorial organization of a copious variety of species and man-made objects reflects not only the encyclopedic spirit of the time but also the overriding belief in the creative power of God. Individually, the animals in Brueghel's paradise landscapes do not have a particular symbolic value, but as a whole they emphasize the magnitude of divine creation.

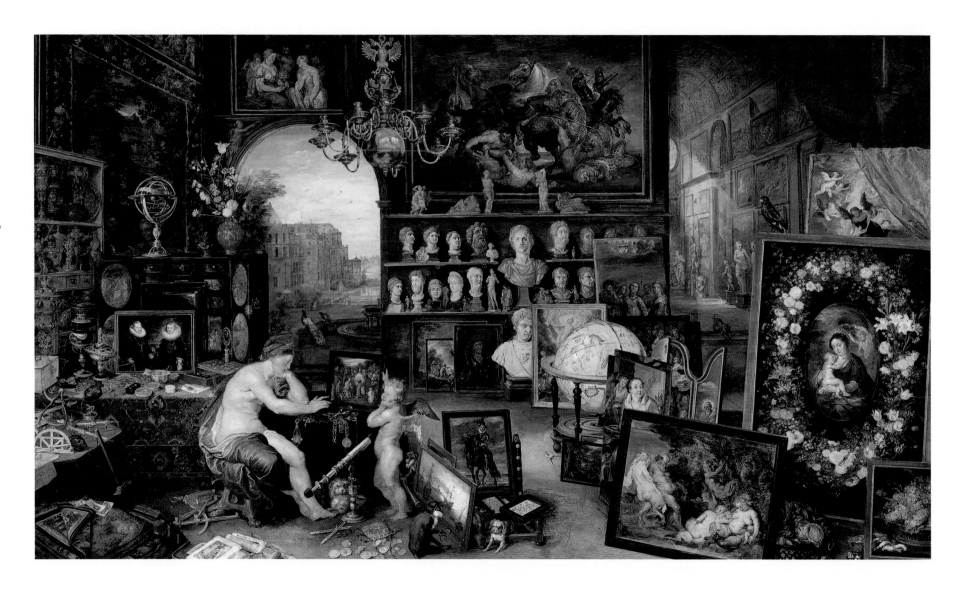

The Courtly Context

Brueghel's paradise landscapes appealed to the aesthetic taste of aristocrats whose collections were filled with such precious objects. His beautiful works, which were often painted on copper, were luxury objects meant for the simple pleasure of viewing as well as contemplation. As a painter in the service of Cardinal Borromeo and the Archdukes Albert and Isabella, Jan had the privilege of being exposed to an elite culture that placed importance on encyclopedic collections. Such stimulating environments it turn contributed to the various levels of meaning and ordering in Brueghel's paradise landscapes.

Brueghel's interest in the categorization and encyclopedic representation of *naturalia* and *artificialia* is evident in his series of the Allegories of the Five Senses of about 1617 in the Prado, Madrid.[144] He produced these paintings, in which the figures are by Rubens, for the Archdukes Albert and Isabella. The Five Senses, like the Four Elements, provided a traditional method of ordering knowledge about man and the material world. The senses were directly connected to the elements, which were often arranged according to man's sensory perception of them. In Henry Cornelius Agrippa's *De Occulta philosophia libri tres*, published in 1533, a table of correspondences links the elements to the senses as well as to other categories, including the four types of animals (birds, fish, quadrupeds, and insects). Brueghel's emphasis on the sensory perception of nature reflects the more experiential approach undertaken by sixteenth-century naturalists and collectors. Aldrovandi, who relied heavily on visual, tactile, and olfactory evidence, believed that "there is nothing in the intellect that is not first in the senses."[145]

The sense of sight, considered to be the most important of the senses, plays a particularly fundamental role in the methodology of natural historical inquiry. Brueghel's *Allegory of Sight* [FIGURE 58] represents the various technical tools of observation that one would have encountered in the *Wunderkammers* of Rudolf II and of Albert and Isabella. In the foreground, the optical instruments include a telescope—a new invention—and a magnifying glass. As noted, Brueghel also prominently displays a telescope, compass, sundial, and surveyor's rod in his

Allegory of Air painted for Borromeo. In that painting the man-made instruments function as complements to the nature around them, while in the context of the *Wunderkammer* represented in the *Allegory of Sight*, they resemble the artworks displayed nearby in their exquisite craftsmanship and invention. This confluence of the realms of art, science, and nature illustrates Brueghel's skillful negotiation of diverse yet interrelated disciplines.

Brueghel's extraordinary depiction of an abundance of natural and man-made symbols of each sense remained unsurpassed. His approach differs from that of the sixteenth-century Netherlandish print designers, who represent a female personification with only one animal and a few attributes.[146] Brueghel pushed the traditional systems of ordering man's senses and his physical world to a new level by classifying all aspects of nature as well as artificial objects. In a letter to Borromeo, Brueghel wrote that he had depicted everything in the world "naer het leven" (from the life) in his paintings of the Five Senses.[147]

The world he refers to differs from the one in his paintings of the Four Elements; the world in question is that of Albert and Isabella. Like the series of the Four Elements, which catalogues nature, the Five Senses series functions as an ideal pictorial catalogue of the material possessions of the Archdukes. Brueghel juxtaposes objects that symbolize the couple's encyclopedic pursuits and

62

Figure 59
Jan Brueghel the Elder and
Peter Paul Rubens, *Allegory of
Touch*, circa 1617. Oil on panel,
65 × 109 cm (25⅝ × 43 in.).
Madrid, Museo Nacional
del Prado, 1398.

ambitions with some actual paintings and sculpture from their collection as well as animals, such as parrots and deer, that formed part of their menagerie. The views of their various castles in Mariemont, Tervuren, and Brussels in the backgrounds identify the courtly culture that prized such precious items. These encyclopedic representations established visually the religious and political authority of the Archdukes. In the *Allegory of Sight* the portraits of Albert and Isabella together with the classical busts of ancient rulers reinforced their political heritage. Their dynastic legitimization is also reinforced in the *Allegory of Touch* [FIGURE 59], which accurately represents some of the armor from the imperial Habsburg family.[148] Brueghel, who probably examined the armory in person, clearly had the detailed knowledge of courtly culture that was necessary to execute such a painting. This series demonstrates both the extent to which Brueghel could adapt his descriptive and cataloguing approach to a variety of subjects and how it functioned on several levels.

The Entry of the Animals into Noah's Ark is another such example, for the prominence of the horse as well as the lions demonstrates how he adapted his classification of animals to a courtly context. The lion and horse are royal symbols, which Brueghel acknowledges in their central placement next to each other in his painting. Similarly, in Emperor Rudolf II's book of animal studies entitled *The Museum*, the lion is depicted first and is followed by horses, including a Spanish white charger. The direct link between the significance of the lion and the Archdukes Albert and Isabella appears in the emblematic print *Vindix Belgii* by Jan Sadeler, which depicts the Southern Netherlands as a lion with a crown inscribed *Isabelle*, above which is the imperial eagle [FIGURE 60].

63

Brueghel's description of a specific type of horse in his painting further emphasizes the classification system, prevalent in the royal courts, of pedigree, race, and nobility of bloodline. This fair horse with a long mane was originally an Arabian steed bred by Spaniards and therefore referred to as a "Spanish" horse. The artist and biographer Karel van Mander points them out in his handbook for painters: "Study the various breeds, such as the horses of Spain, elegant of contour."[149] He also notes Brueghel's particular type: "A beautiful dapple-gray color, which is not to be made to be lacking, by which the hide looks as if entirely set with scales, is also pleasing to see."[150] These magnificent and uncommon creatures were considered the highest class of horse and therefore associated with royalty.[151] The horse's elevated representation in art and

Figure 61
Peter Paul Rubens,
Daniel in the Lion's Den,
circa 1612. Oil on canvas,
224.3 × 330.4 cm (88⁵⁄₁₆ ×
130¹⁄₁₆ in.). Washington,
National Gallery of Art,
1965.13.1. Alicia Mellon
Bruce Fund.

Figure 62
Attributed to the Workshop
of Peter Paul Rubens, *The
Leopards*, late seventeenth–
early eighteenth century.
Oil on canvas, 205 × 317 cm
(80¾ × 124⅞ in.). Montreal,
Museum of Fine Arts,
1975.17. Photo: Brian Merrett.

Figure 63
Follower of Peter Paul Rubens,
*Equestrian Portrait of the
Archduke Albert*, circa 1609.
Oil on canvas, 109.4 × 75.4 cm
(43⅛ × 29⅝ in.). Vaduz
Castle, Liechtenstein
Princely Collection, GE 402.

natural history, which reflects its status as one of the most noble of creatures and man's indispensable companion, further supports its hierarchical treatment in Brueghel's painting. In his painter's handbook, Van Mander begins his chapter on the representation of animals with the horse. Natural historians, such as Gesner and Aldrovandi, also emphasized the high status of the horse in the hierarchy of animals and devoted the most attention to it in their catalogues. Aldrovandi focuses almost entirely on the horse in Volume VII of his books on quadrupeds.

Brueghel's depictions of the horse, lions, and leopards are the only exceptions to his experiential approach in *The Entry of the Animals into Noah's Ark*. He imitated them from Peter Paul Rubens's paintings *Daniel in the Lion's Den*, *The Leopards*, and the *Equestrian Portrait of the Archduke Albert*, the latter two works now lost and only known to us through copies [FIGURES 61, 62, 63]. Brueghel had firsthand knowledge of these paintings, since the *Equestrian Portrait of the Archduke Albert* and *Daniel in the Lion's Den* appear in his *Allegory of Sight*

66

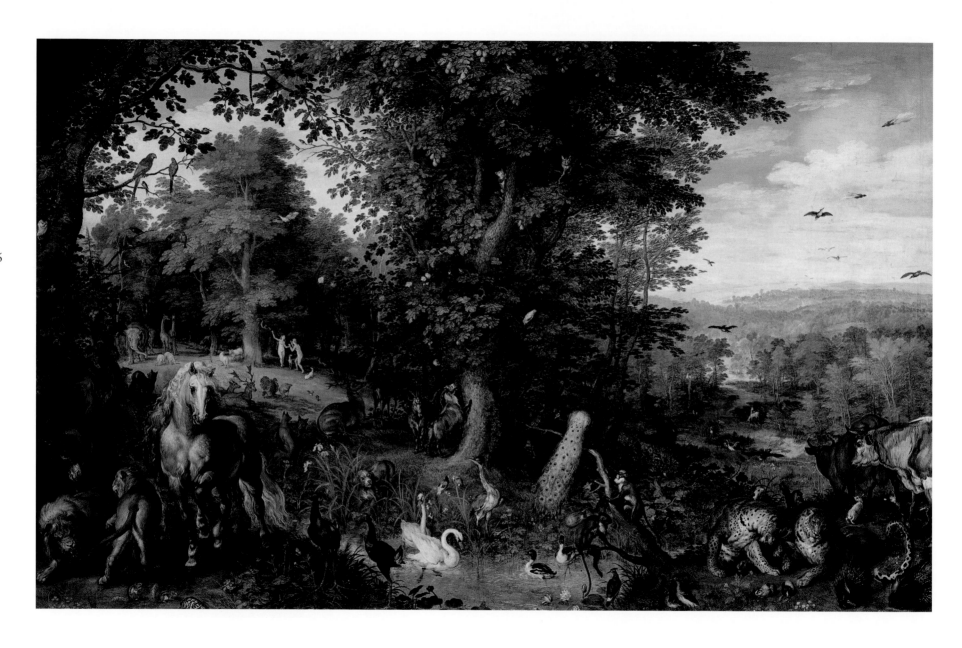

Figure 64

Jan Brueghel the Elder,
*The Temptation of Adam
and Eve*, 1612. Oil on panel,
50.3 × 80.1 cm (19⅞ ×
31½ in.). Rome, Doria
Pamphilj Gallery, FC 341.

Figure 65

Peter Paul Rubens,
The Duke of Lerma, 1603.
Oil on canvas, 283 × 200 cm
(113⅕ × 78¾ in.).
Madrid, Museo Nacional
del Prado, 3137.

of about 1617, painted with Rubens, and *The Leopards* appears in the *Allegories of Sight and Smell* (Prado, Madrid). Unfortunately, *Daniel in the Lion's Den* and *The Leopards* are not dated, but we know that in 1618 Rubens offered them for sale to the British connoisseur and statesman Sir Dudley Carleton, who subsequently purchased them.[152] However, these works must have an earlier *terminus ante quem* of about 1612, which is when the lions and leopards first appear in Brueghel's *Temptation of Adam and Eve* [FIGURE 64].[153] Brueghel also depicted some of the other species in this slightly earlier painting, but he arranged the animals differently, placing the horse and lions on the far left side of the composition and the leopards on the right. Furthermore, he did not include as many varieties of creatures and made no attempt to group the species according to their classifications. Apparently, he had a different purpose in mind when he painted *The Entry of the Animals into Noah's Ark* [FIGURE 1] shortly thereafter.

Brueghel's frontal view of the horse in both *The Entry into Noah's Ark* and *The Temptation of Adam and Eve* was clearly inspired by Rubens, who popularized this type of authoritative representation. At least five years before painting his *Equestrian Portrait of the Archduke Albert*, Rubens had been commissioned to portray the Duke of Lerma on horseback [FIGURE 65]. This portrait of Lerma, one of the most powerful figures at the Spanish court, resembles the one of the Archduke in its frontal view and pose of the horse. Apparently, the model for Lerma's painting was Giambologna's impressive *Equestrian Monument of Cosimo I* on the Piazza della Signoria in Florence (1587–99).[154] Since the Duke admired Giambologna's work, Rubens drew a sheet of studies after the sculptor's

67

horse during his stay in Florence shortly before he painted the portrait.[155] Rubens was apparently not satisfied with the outcome of his horse's pose in *The Duke of Lerma*, since he studied live models for his painting *The Riding*

68

School [FIGURE 66] upon his return to Brussels in prepa-
ration for his portrait of Archduke Albert.[156] Rubens,
a courtier, was naturally knowledgeable about the art of
riding and had access to horses that he could study from
life. The "collected trot," or *passage*, of Lerma's horse,
which he adopted from Giambologna, had a rather
stiff appearance. As a result of his direct observations in
Brussels, Rubens altered the horse's trot in Albert's
portrait by raising its right hind leg, thereby providing it
with a more lively and energetic appearance.

For *The Entry of the Animals into Noah's Ark*,
Brueghel referred to the dapple-gray horse on the left side
of Rubens's *Riding School*, which can be identified as a
Spanish/Arabian stallion.[157] The horse in Rubens's portrait
of Albert is not dapple-gray, but its pose is the same as
that of the horse in Brueghel's work. Some of Brueghel's
earlier depictions of horses, such as the one in *The
Creation with Adam* of 1594, have dapple-gray coloring,
but their poses and appearance are somewhat different,

and not nearly as imposing. The most closely related rep-
resentation appears in Brueghel's small oil painting
Extensive Landscape with View of the Castle of Mariemont
[FIGURE 67]. This work shows Albert in minute scale in
the lower left corner with a white horse. Here the Spanish
horse and the castle of Mariemont in the distance are
displayed as prized possessions of the Archduke and as
attributes of his authority.

As in the case of the horse, Brueghel's lion and
lioness group replicates Rubens's work, specifically the
playful pair of felines in *Daniel in the Lion's Den*.
Brueghel apparently relied on his friend's vigorous and
naturalistic depiction of lions, because he had not com-
pletely mastered their representation a few years earlier in
his own *Daniel in the Lion's Den*, which he painted for
Cardinal Borromeo [FIGURE 68].[158] Although Brueghel's
lions are well painted in this work, the leopards appear
a bit awkward. He depicts them in various poses, playing
and fighting with one another. In the dark section of
the den, the lion seen from the rear foreshadows the one
in *The Entry of the Animals into Noah's Ark*. One cannot
help but wonder whether Rubens drew his inspiration
for the subject matter from Brueghel's *Daniel in the Lion's*

Figure 67
Jan Brueghel the Elder,
*Extensive Landscape with View
of the Castle of Mariemont*,
circa 1608–11. Oil on canvas,
84.7 × 130.8 cm (33⅜ ×
51½ in.). Virginia Museum
of Fine Arts, The Adolph D.
and Wilkins C. Williams Fund,
53.10. Photo: Ron Jennings.

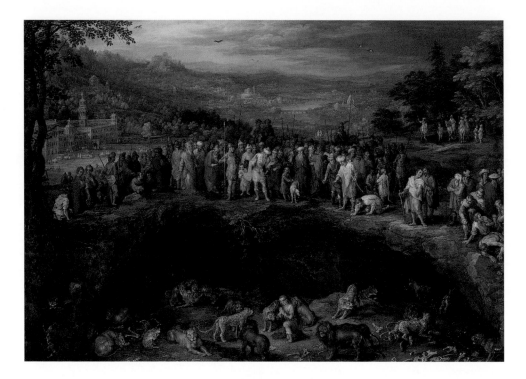

Figure 68
Jan Brueghel the Elder,
Daniel in the Lion's Den, 1610.
Oil on copper, 28.5 × 38.5 cm
(11¼ × 15⅛ in.). Milan,
Pinacoteca Ambrosiana, 62.

Figure 69
Peter Paul Rubens, *Lioness*,
circa 1612. Black and yellow
chalk heightened with gray
wash and white gouache,
39.6 × 23.5 cm (15⅝ × 9¼ in.).
London, British Museum,
1994-5-14-46.

70

Den, since it seems unlikely that he painted his version before 1610.[159]

Rubens based his lions, like the horse, on Italian Renaissance sculptures as well as live specimens. He may have derived the lion in his *Daniel in the Lion's Den* [FIGURE 61] from an Italian bronze produced by the workshop of Francesco Susini.[160] He based his lioness on a Paduan Renaissance bronze sculpture, of which he made a few sketches, studying it from different angles, especially from the rear [FIGURE 69].[161] Rubens infused his lioness with vigorous movements and a lifelike quality, particularly through the addition of color. He used yellow chalk

with gray wash and white gouache to convey the texture of the animal's coat.

Rubens wrote to Dudley Carleton that he had studied the lions from life, which implies that Rubens felt that his direct observations outweighed his reference to sculptures. In his essay *De Imitatione statuarum*, Rubens insisted that an artist seeking perfection must have a profound knowledge of ancient sculpture.[162] For him, earlier works were useful only insofar as they provided a foundation for the imitation of nature. Rubens's contemporary Van Mander shared his views and, although he encouraged artists to copy sculptural models and praised the ancients'

representations of animals,[163] he believed that simply copying a sculpture was inadequate and that it had to be complemented by studying the animal from life. Rubens's studies after sculptures prepared him for the more difficult task of drawing from the live model. His *Sheet of Lions* juxtaposes his sketches after sculptures with studies from life [FIGURE 70]. The lioness after the Paduan sculpture appears on the top of the sheet, while studies of a lion seated, sleeping, and yawning are on the bottom. The eighteenth-century Dutch biographer Jacob Campo Weyerman described in vivid detail how Rubens had a lion brought to his studio by its keeper in order to observe it carefully.[164] Perhaps there is some truth to the story, since Rubens particularly liked the way the lion yawned and asked the keeper to tickle him so that he could capture this pose again. Whether or not one believes Weyerman's anecdote, Rubens certainly enlivened his representations of animals by depicting their behavior and expressions, while also referring to ancient and Renaissance sculptures.

Brueghel's and Rubens's imitation of other works can be situated within the Netherlandish tradition of artists copying animals from earlier sources. As was mentioned earlier, Collaert and Hoefnagel imitated many of the illustrations in Bol's manuscript and in Gesner's natural history encyclopedia, which they considered to be an authoritative source. These painters rarely copied their sources faithfully but improved upon them and placed them in different contexts, as Brueghel did. Apparently, Brueghel had no qualms about juxtaposing his animals studied from life with those cited from Rubens. This approach resembles his method of painting a flower still life, in which he painted most of the flowers from life and copied some from botanical illustrations.[165] Natural

71

historians also relied on secondary sources for illustrations of certain species.[166] Faithful resemblance to an actual animal qualified it as naturalistic whether or not it depended on an artistic source.[167]

The artistic lineage of Brueghel's horse helps us better understand the way it was perceived. Rubens's *Equestrian Portrait of the Archduke Albert* [FIGURE 63] inspired a very popular portrait type and was imitated by his workshop, Anthony van Dyck (1599–1641), and others.[176] For this reason, the beholder of Brueghel's painting probably made the connection to Rubens's horse as well as to the Archduke. Since Brueghel clearly did not have to copy an animal of which sufficient live models existed, he evidently intended to make a statement by imitating Rubens. Brueghel, like Rubens, had substantial knowledge of horses and made numerous studies of them in his drawings [FIGURE 71]. He therefore appears to have paid tribute to his friend's monumental and naturalistic depiction of the horse as well as to its absent rider, the Archduke Albert. By taking Rubens's horse out of its original context, Brueghel slightly altered its significance; yet the allusion to royal and dynastic power remains despite the absence of a rider.

Brueghel's allusion to his main patron, Archduke Albert of Austria, explains the prominence of the horse in *The Entry into Noah's Ark*. This type of horse apparently had great significance for Albert, whose dapple-gray horse saved his life in the battle of Nieuport and Ostend in 1600.[168] The horse died after being shot in the neck and was glorified in poems, which often referred to his white forehead. After this battle, which the Spaniards lost, a white Spanish horse was presented to Prince Maurits of Nassau as part of the booty seized by the Dutch

troops. Maurits had himself portrayed on the horse by Pauwels van Hillegaert as a testimony to the suppression of the Spaniards by the Dutch.[169] Roelandt Savery depicted this horse in his *Animals around a Pond* in 1606, and Jacques de Gheyn painted a life-size portrait of it for Maurits in 1603.[170] In his *Schilder-Boeck*, Van Mander describes De Gheyn's portrait of this majestic horse:

> Then it happened that in the battle in Flanders His Excellency Count Maurice had won a splendidly beautiful horse from the illustrious Archduke and he let De Gheyn know that he wished to have it painted by him, as large as life, which he gladly accepted to do, all the more because he had so much enthusiasm for large work.[171]

The Archdukes probably would have appreciated Brueghel's image, since they prized their horses so much that they had some of them preserved after their death. Hans Georg Ernstinger saw the preserved skins of horses in the archducal stables in 1606.[172] One was supposedly the skin of the horse ridden in the Archdukes' Joyous Entry into Brussels on September 5, 1599, and the other was of the white horse that saved Albert, which had a sign inscribed "Il cavallo noble" (the noble horse). In Isabella's letter describing the Entry into Brussels to her brother Philip III of Spain, she wrote how she and her husband were

> mounted on two jennets, white as snow . . . because a very old prophecy declared that, as long as two sovereigns had not entered into Brussels on white horses, there would be no peace, and here people give much credence to the prophecy.[173]

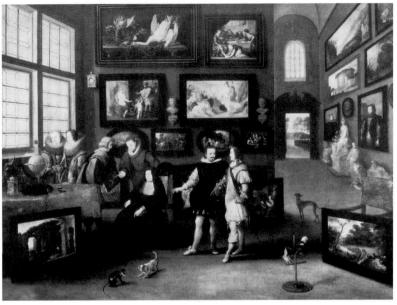

Interestingly, such white horses were thereafter referred to as Isabel-colored.[174]

The prominence of the royal horse as well as some of the other animals in Brueghel's painting suggests that he produced this work for the Archdukes or at least with them and their collection of animals in mind. Perhaps Brueghel made this reference as an expression of his gratitude to Albert and Isabella, since after almost six years of requesting tax exemptions from them, he was finally relieved of certain tax obligations in 1613, the same year he painted this work.[175] Such a paradise landscape would have complemented the Archdukes' encyclopedic collection and would have functioned as a pictorial counterpart to their menagerie.

Whether or not any doubt still remains that the Archdukes owned Brueghel's *Entry of the Animals into Noah's Ark*, they probably had a similar paradise landscape by him in their collection, as evidenced by a cabinet painting by Willem van Haecht depicting the gallery in their castle at Tervuren. This painting, *The Salon of the Archduchess Isabella* [FIGURE 72], reflects Isabella's interest in natural and man-made objects, as exhibited in her menagerie and art collection.[177] The gallery illustrates the encyclopedic nature of seventeenth-century collections of art, animals, and scientific instruments. The Archduchess, dressed in the habit of the Poor Clares, which she wore after Albert's death, is seated in a room filled with landscape, still life, and animal paintings by some of

her favorite seventeenth-century Flemish artists, in particular Joos de Momper, Frans Snyders, Denis van Alsloot, and Daniel Seghers. The gallery also includes a paradise landscape by Brueghel, sculpture, fine objects, a globe, parakeet, cockatoo, monkey, and dog. These animals and birds recur in some of Brueghel's paintings, and the monkey, a *Cercopithecus preussi*, is the same as the one in *The Entry of the Animals into Noah's Ark*. Van Haecht's imitation of motifs from Brueghel suggests that this scene could be imaginary. He may have also worked from memory, since his depiction of a Brueghel paradise landscape prominently placed in the foreground does not recall a specific work. It is important to note, however, that this is the only known cabinet painting that includes such a landscape, which is surprising considering the number of versions of the paradise theme that Brueghel and his workshop produced.

The Archdukes' menagerie, like Brueghel's *Entry of the Animals into Noah's Ark* [FIGURE 1], reflected the political climate in the Netherlands during the Twelve Years' Truce (1609–21). In Brueghel's painting, antagonistic and hostile species, such as ducks and dogs and lions and horses, coexist harmoniously in a single landscape, possibly referring to the peace experienced by the Netherlands at the time. Similarly, the menagerie encouraged the peaceful observation of species, as opposed to the violent spectacle of animal combats. The maintenance of peace was an overarching theme in Netherlandish culture, and numerous works make references to the Truce.[178] An optimistic spirit, much like that expressed by Brueghel's emphasis on the wonders of God's creations in his painting, prevailed as a result of the treaty.[179] This mood was expressed by the *Leo Belgicus*, an elaborate map of the entire Netherlands in the form of a lion that was produced during the Truce; it recalls the prominence of the lions in the foreground of Brueghel's work.[180] Brueghel witnessed the effects of the peace treaty when he went on an official mission to the Dutch Republic with Rubens and Hendrik van Balen in 1613, the same year that he produced his painting; it therefore seems plausible that he may, indeed, have alluded to the Truce.

In *The Entry of the Animals into Noah's Ark* and in the Archdukes' menagerie, the species from all corners of the globe make certain geographical claims about the lands controlled by the Spaniards and the Habsburgs.[181] Such a message would have been particularly relevant in the midst of a territorial struggle with the Dutch Republic (despite the Twelve Years' Truce, the Spaniards still wanted to regain control over the northern provinces). Similarly, the Renaissance menagerie of wild animals owned by the Medici dukes in Florence helped to assert their power symbolically.[182] Rudolf II, through his encyclopedic collection of art, animals, and *naturalia*, perceived himself as the possessor of the wonders of the universe; in fact, he had himself portrayed in such a manner. His brother the Archduke Albert had similar aspirations, as demonstrated by the series of the Allegories of the Five Senses, in which Brueghel represents the archducal court as the center of sensory experience.[183] Together with these paintings, *The Entry of the Animals into Noah's Ark* symbolized the magnitude and diversity of the natural and man-made creations, whether real or ideal, in the collection of the Archdukes. A court culture that placed a premium on a discriminating approach to collecting, as opposed to conspicuous consumption, appreciated an artist like Brueghel, who could order its

prized objects. Instead of overwhelming the senses with a profusion of random specimens and objects, Brueghel depicts a universe with a comprehensive structure.

Brueghel's *Entry of the Animals into Noah's Ark* engages various levels of meaning—courtly, religious, scientific, and artistic. On the one hand, his classification of animals represents the new methodology of natural history. Brueghel's application of taxonomic tools in turn relied on the resources of the court, since only there could he encounter the range of species necessary to properly implement this scientific language. Through his biblical contextualization of animals, Brueghel situated the zoological ordering of species within a more traditional framework. Moreover, Brueghel's imitation of the monumental representations of animals by his fellow court painter Rubens endowed the horse in particular with specific references to the Archdukes. The subject matter of the painting reflects the concerns of the Counter-Reformation, since the Ark symbolized the Church and its salvation of mankind. This message had particular significance within the court of Albert and Isabella, whose aims involved the restoration of the Catholic Church's authority in the Netherlands.

Brueghel's skillful and naturalistic depiction of animals placed within religious and scientific frameworks appealed to his Catholic patrons, who had an encyclopedic and spiritual interest in nature. Despite the different nationalities and roles of Cardinal Borromeo and the Archdukes, they shared a pansophic view of the world; this *Weltanschauung* facilitated Brueghel's ability to traverse geographical, religious, and political realms. Like his friend Rubens, Brueghel was a Netherlandish painter who could speak the cultural language of his Spanish and Italian patrons. In fact, Rubens and Brueghel occasionally acted officially on behalf of the Archdukes during and after the Twelve Years' Truce. Brueghel completed his own artistic diplomatic mission in his harmonious convergence of different approaches. His paradise landscapes symbolized the ideal and peaceful world that the Archdukes tried to re-create from the remnants of the war-torn Netherlands, and the wondrous universe in which Borromeo found solace and inspiration.

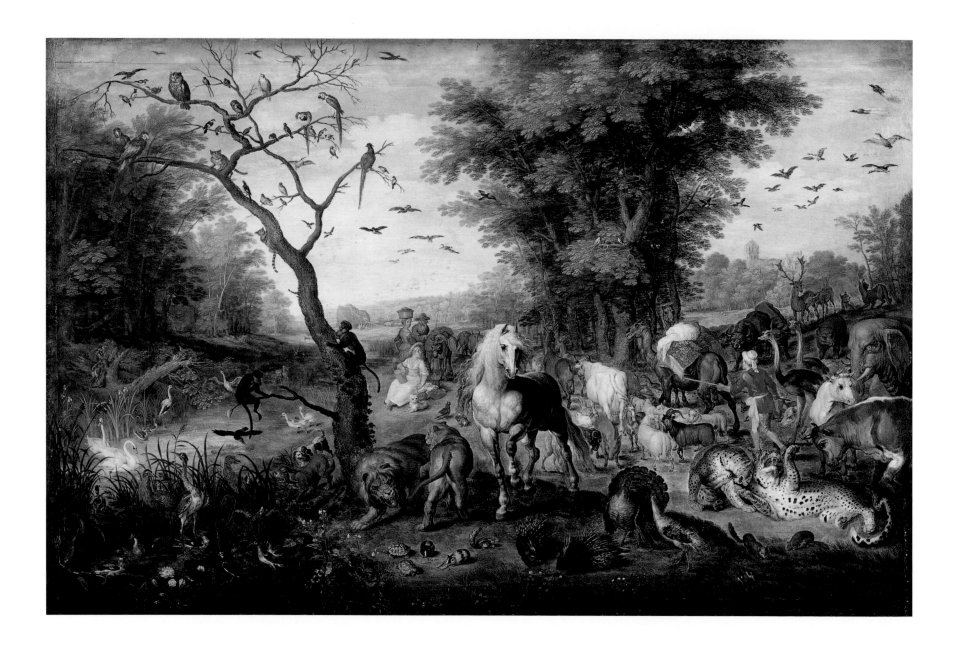

The Legacy of *The Entry of the Animals into Noah's Ark*

he *Entry of the Animals into Noah's Ark* represents the result of Brueghel's progressive efforts to paint animals in a naturalistic and orderly manner. His extensive exposure to the Archdukes' menagerie allowed him to expand his repertory of animals and thereby apply more methods of classification to his work. The paradise landscapes that he painted thereafter tend to reuse many of these animal motifs. Apparently, he no longer found it necessary to introduce many new species to his encyclopedic pictorial catalogue. He now had the freedom to experiment with his substantial material by producing a variety of works.

As far as we know, Brueghel painted only one exact replica of this work, now in the National Museum, Budapest [FIGURE 73]. As in the case of Joachim Patinir's exact replicas of his own landscapes, such works were probably commissioned.[184] A comparison of certain motifs in the Getty and Budapest paintings demonstrates that a drawing was used to transfer them precisely. For example, the height of the lioness is 113 mm and its width is 44–45 mm in both paintings. The stick that the shepherd holds measures 36 mm in both works. A section of the tree trunk below the monkey has the same measurements of 32 mm in both as well.[185] The panels were originally approximately the same size, since sections were added later to all of the sides of the Budapest version.[186] Since the compositions are exactly the same, it seems likely that Brueghel traced the entire original work and then transferred the drawing to another panel by pricking and pouncing the cartoon. The Getty painting was probably painted first, since slight changes, such as the shifting of the turkey's legs and the horse's ears, appear in the paint layer [FIGURE 13].[187] The careful attention required for such an exact replication could explain the greater number of freely painted versions that Brueghel produced.

Overall, Brueghel tended not to replicate his animal types faithfully but rather adjusted their poses depending on their placement within the composition. In every paradise landscape that adheres to the Noah's Ark type, the animals appear with a slight variation. In *The Entry of the Animals into Noah's Ark* that is signed and dated 1615, in the Wellington Museum, London, Brueghel reduced the

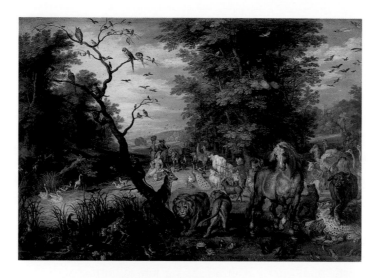

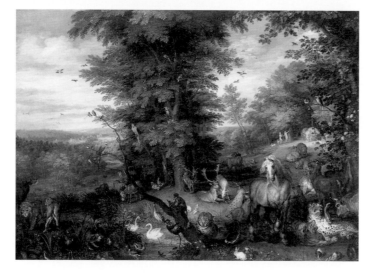

scale of the Getty prototype, which required him to cluster the animals more tightly together [FIGURE 74]. Nonetheless, Brueghel still managed to depict the creatures with incredible accuracy and detail. This luminous painting on copper demonstrates how Brueghel continued to apply his miniaturist approach throughout his career.

The horse, lions, and leopards in the Wellington *Noah's Ark* refer more closely to those in the painting entitled *Adam and Eve in the Garden of Eden* in the Royal Collection at Hampton Court, painted the same year [FIGURE 75]. However, the landscape composition of the *Adam and Eve* painting has much more in common with *The Temptation of Adam and Eve* in the Doria Pamphilj Gallery, dated 1612 [FIGURE 64]. In the Hampton Court painting Brueghel retained the central cluster of trees, but inverted the composition by placing the vista on the left. He included the tree as a *repoussoir* motif (an object in the extreme foreground used as a contrast and to increase the illusion of depth) on the right side instead of the left and painted a significantly reduced version of the *Noah's Ark* bird tree in the foreground. He also decided to group the horse and leopards together on the right and isolate the lions on the left. This calculated placement corresponds to Van Mander's discussion of arranging a composition so that elements are grouped on either side to allow room for a vista of landscape in the center.[188]

The painting entitled *Adam and Eve in Paradise* in the Mauritshuis [FIGURE 76], which places the animals within a different landscape setting, is another variation of the *Noah's Ark* and *Adam and Eve* compositions. The sketchy underdrawing in the Mauritshuis painting reveals that Brueghel laid out the main elements of the landscape and animals.[189] He adjusted the composition to provide an

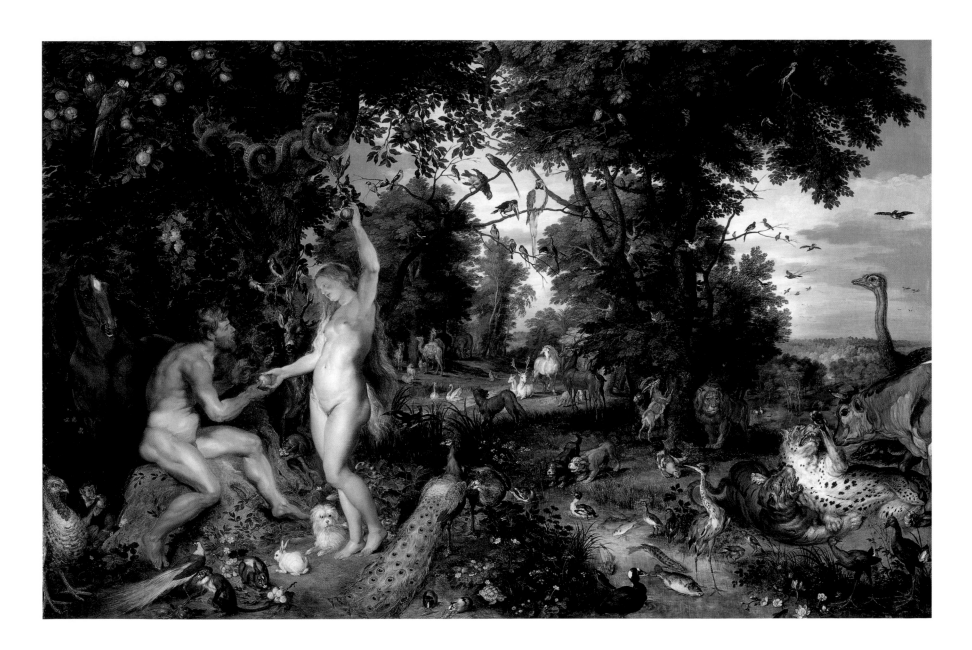

appropriate space for Rubens's figures, which were painted first. As the only paradise landscape with rather prominent and large figures, and more significantly the only such painting by Brueghel's esteemed friend Rubens, this work's animal motifs had to function in a slightly different manner. The horse and lions, which have such an imposing presence in *The Entry of the Animals into Noah's Ark*, now play a more secondary and complementary role. The dapple-gray horse remains in the center, but only in the far distance, while a brown horse peers out from behind the left side of Adam. The landscape setting of the Mauritshuis painting more closely resembles the earlier version, namely *The Temptation of Adam and Eve* of 1612 in the Doria Pamphilj [FIGURE 64]. What becomes evident here is how the landscape dictated the placement of the animals. Since the stream in the center of both works breaks up the composition, the horse was pushed to the left side of the foreground while the leopards and oxen remained on the right as in *The Entry of the Animals into Noah's Ark*.

Like the sixteenth-century natural history catalogues, *The Entry into Noah's Ark* became a type of reference work, which Brueghel's son Jan the Younger and his workshop and followers would continue to emulate. However, the copies and variations by others reveal not only the copyists' limited skills but also their lack of understanding of the species described by Brueghel. The copies often appear awkward and do not replicate the appearance of the animal. Herein lies the crucial difference between direct observation and imitation of intermediary sources, such as drawings, by an unskilled copyist. In the replica by Brueghel's workshop in the Lazaro Galdiano Museum, Madrid, the birds on the right are larger and not as

freely painted as those in the Getty painting, although the landscape retains a similar quality [FIGURE 77].[190] In a version by a follower, the tight, dark outlines around the animals and their different coloration reveal the hand of a copyist, who may have worked from a pattern drawing rather than a painting [FIGURE 78]. The artist's inclusion of the unicorn in the background is inconsistent with Brueghel's avoidance of mythical creatures in his paradise landscapes. Despite the various levels of quality, the numerous replications of Brueghel's inventions attest to the popularity of the theme and to a demand that continued into the late seventeenth century.

This widespread imitation of Brueghel's paintings parallels the repetition of natural history illustrations. Mid- to late-seventeenth-century naturalists, such as John Jonston, continued to use Gesner's and Aldrovandi's illustrations, even though they had replaced their texts with more empirical ones.[191] They discarded the traditional emblematic categories, such as allegories and mythologies, since they were based on outdated and unreliable sources. The illustrations, on the other hand, were considered to be the result of firsthand observations and were therefore preserved. Apparently, visual descriptions had more value and veracity than written ones. Similarly, Brueghel's representations continued to serve as models for the following generations of Netherlandish artists, such as Jan van Kessel (1641–1680). Like the artistic and scientific authorities on animals cited by Brueghel, such as Rubens and Aldrovandi, he in turn became an authority on the description of nature for artists who sought a worthy model to emulate.

By viewing Brueghel in a broader context as well as placing him within a general survey of art of the seven-

teenth century, one can appreciate his impact on the art produced after his death. On the one hand, Brueghel's approach was immersed in the culture of the sixteenth century, which perceived the world in a pansophic manner. However, his experiential approach and taxonomic methodology also display characteristics of the empirical language of the seventeenth century. As a transitional figure, he provides the link between the Renaissance focus on texts and their interpretation and the seventeenth century's emphasis on "seeing and representation."[192] Brueghel's composite paradise landscapes, with their amalgamation of an abundant variety of species, retain the Mannerist qualities of his era, yet his forest and village landscapes represent the world around him in a naturalistic

manner that would be adopted by following generations of Dutch landscape painters. Brueghel's use of perspective, surface description, and detail became key elements in northern Baroque art. Although he represented a culture strongly imbedded in the Counter-Reformation, he also found pleasure in depicting the unadorned world around him, never growing weary of its "common-ness" and physical reality. The naturalistic description of animals certainly formed the basis of Brueghel's approach, but his ultimate quest for an appropriate framework within which to present various species led to his formulation of a novel type of encyclopedic representation that incorporated the scientific, religious, courtly, and artistic language of his time.

Notes

1 For Brueghel's flower still lifes, see K. Ertz, *Jan Brueghel der Ältere, 1568–1625* (Cologne, 1979); M. Paulussen, "Jan Brueghel d. Ä. 'Weltlandschaft' und Enzyklopädisches Stilleben" (Ph.D. diss., Rheinisch-Westfälischen Technischen Hochschule Aachen, 1997); B. Brenninkmeyer-De Rooij, *Roots of Seventeenth-Century Flower Painting* (Leiden, 1996); and P. Taylor, *Dutch Flower Painting, 1600–1720* (New Haven, 1995).

2 See A. Grafton, *New Worlds, Ancient Texts* (Cambridge, Mass., and London, 1992); A. Grafton, *Defenders of the Text: The Traditions of Scholarship in an Age of Science, 1450–1800* (Cambridge, Mass., 1991); and M. Foucault, *The Order of Things: An Archaeology of the Human Sciences* (New York, 1970).

3 "Quanto il quadro del Ill.m Cardinal del Arca d'Noi, non m'a schritto: ne anco la letra non va risposta: aspettera l'ordina sua." Brueghel to Borromeo, April 22, 1611; G. Crivelli, *Giovanni Brueghel,*

pittore fiammingo, ò sue lettere esistenti presso l'Ambrosiana (Milan, 1868), p. 169.

4 Shortly after his return from Italy, Brueghel painted a small copper work entitled *The Flood* in 1601 (Kunsthaus, Zurich). It resembles Michelangelo's fresco, since it shows the sinners in the foreground and the ark in the background. See *Breughel-Brueghel: Flämische Malerei um 1600, Tradition und Fortschritt,* exh. cat. (Essen, Kulturstiftung Ruhr Essen, and Vienna, Kunsthistorisches Museum, 1997), no. 32.

5 E. Kirschbaum et al., *Lexikon der Christlichen Ikonographie* (Rome, Freiburg, Basel, and Vienna, 1968), vol. 1, p. 179.

6 For De Vos's print, which is quite different from Brueghel's composition, see F. W. H. Hollstein, *Dutch and Flemish Etchings, Engravings and Woodcuts, 1450–1700,* vol. 45, C. Schuckman, comp., D. de Hoop Scheffer, ed. (Rotterdam, 1995–96), no. 56.

7 For Savery's paradise landscapes, see K. J. Müllenmeister, *Roelant Savery* (Freren, 1988).

8 Only a few earlier variants of the paradise landscape genre exist in paintings, most notably Hieronymus Bosch, *Garden of Eden* of circa 1500 (Prado, Madrid), Lucas Cranach I, *Adam and Eve in Paradise* of 1530 (Kunsthistorisches Museum, Vienna), Herri met de Bles, *Garden of Eden* of 1525–30 (Mauritshuis, The Hague), Frans Pourbus I, *Orpheus Enchanting the Animals* of 1570 (Pitti Palace, Florence), and Jacopo and Leandro Bassano's paintings of The Entry into Noah's Ark from the 1570s (most notably that in the Prado, Madrid). See also C. van de Velde, A. Balis, et. al., *Het Aards Paradijs: Dierenvoorstellingen in de Nederlanden van de 16de en 17de eeuw* (Antwerp, 1982).

9 For a recent discussion of this painting, see E. M. Kavaler, *Pieter Bruegel: Parables of Order and Enterprise* (Cambridge, England, and New York, 1999). See also H. W. Janson, *Apes and Ape Lore in*

the Middle Ages and Renaissance (London, 1952), pp. 154–57.

10 For a description of Brueghel's painting technique in this work, see M. Gifford, "Landscape Painting Style and Technique: Fidelity to the Sixteenth Century Tradition in Early Seventeenth Century Landscape Production" in *Colloque XII pour l'étude du dessin sous-jacent et de la technologie dans la peinture*, R. van Schoute and H. Verougstraete, eds. (Louvain-la-Neuve, 1999), pp. 177–88.

11 I am grateful to Prof. John Allman at the California Institute of Technology for identifying this monkey, which he considers an accurate study from life. See J.-M. Lernould, "Classification and Geographical Distribution of Guenons: A Review," *A Primate Radiation: Evolutionary Biology of the African Guenons*, A. Gautier-Hion, F. Bourlière, and J.-P. Gautier, eds. (New York and Cambridge, England), vol. 1, p. 4.

12 Glück made the connection between the sketch and Brueghel's painting in 1912. G. Glück, *Trésor de l'art Belge au XVIIe siècle* (Brussels and Paris, 1912), reprinted in G. Glück, *Rubens, Van Dyck und ihr Kreis* (Vienna, 1933), p. 354.

13 Another oil sketch on panel attributed to Brueghel depicts ducks and other birds, many of which, such as the northern lapwing, recur in *The Entry into Noah's Ark*. I must reserve judgment on the authorship of this sketch, since I have not seen it in person. For an illustration, see sale cat., Musée Galliera, Paris, November 23, 1972. For a discussion of this sketch and others by Brueghel and his circle, see A. Faber Kolb, "Cataloguing Nature in Art: Jan Brueghel the Elder's Paradise Landscapes" (Ph.D. diss., University of Southern California, 2000), pp. 16–20.

14 Painters such as Albrecht Dürer, Jacques de Gheyn, and Roelandt Savery made life studies of animals in color and showing them from various angles. See Faber Kolb (note 13), pp. 25–28.

15 For a discussion of representing nature *ad vivum*, see C. Swan, "*Ad vivum, naer het leven*, From the Life: Defining a Mode of Representation," *Word and Image* 11, no. 4 (1995), pp. 353–72. An engraving of *Minerva Leads Painting to the Liberal Arts* by Aegidius Sadeler is accompanied by a text that underscores the eternal quality of painting. The first part of the inscription refers to easel painting: "Nobile si quid humus, si quid tenet Amphritite / Spectatu dignum si quid olympus habet / Aemula naturae dextra pictura potenti / Semper victuras transtulit in tabulas." (When the earth is home to something noble, when the sea, when the heavens contain something worthy of sight, then skilled Painting, competing with mighty Nature, has transferred it to wooden panels, which will live on forever.) As translated by T. Vigneau-Wilberg, "*Pictor Doctus*: Drawing and the Theory of Art around 1600," in E. Fucíková et al., *Rudolf II and Prague: The Court and the City* (Prague, London, and New York, 1997), pp. 179–80. Here, the transience of nature, a common theme of the still life, is contrasted to the permanence of its representation on panel.

16 F. Ames-Lewis, *Drawing in the Italian Renaissance Workshop* (London, 1983), p. 96.

17 Leonardo da Vinci, quoted in Ames-Lewis (note 16), p. 101.

18 See P. Jones, *Federico Borromeo and the Ambrosiana: Art and Patronage in Seventeenth-Century Milan* (Cambridge, England, and New York, 1993), p. 81.

19 Brueghel to Borromeo, September 5, 1621; Crivelli (note 3), p. 272; Ertz (note 1), pp. 304–306; and Jones (note 18), pp. 84–86, 238. For a discussion of Brueghel's garland paintings, see D. Freedberg, "Science, Commerce, and Art: Neglected Topics at the Junction of History and Art History," in *Art in History, History in Art: Studies in Seventeenth-Century Dutch Culture*, D. Freedberg and J. de Vries, eds. (Santa Monica, 1991), pp. 376–428.

20 For the Archdukes' paintings collection, see M. de Maeyer, *Albrecht en Isabella en de Schilderkunst* (Brussels, 1955).

21 For Philip the Good's menagerie as well as the others discussed, see P. Saintenoy, *Les Arts et les artistes à la cour de Bruxelles* (Brussels, 1932–35), vol. 1, pp. 72–73, 76; and G. Loisel, *Histoire des ménageries de l'antiquité à nos jours* (Paris, 1912), vol. 1, p. 230.

22 F. Checa, *Felipe II: Mecenas de artes* (Madrid, 1992), p. 247; and H. Trnek, "'Und ich hab aber all mein lebtag nichts gesehen, dass mein hercz also erfreut hat als diese ding.' Exotica in habsburgischen Kunstkammern, deren Inventare und Bestände," in *Exotica:*

Portugals Entdeckungen im Spiegel fürstlicher Kunst- und Wunderkammern der Renaissance, exh. cat., W. Seipel, ed. (Vienna, Kunsthistoriches Museum, 2000), p 28.

23 A. Smolar-Meynart, A. Vanrie, M. Soenen, L. Ranieri, and M. Vermeire, *Le Palais de Bruxelles: Huit siecles d'art et d'histoire*, exh. cat. (Brussels, Palais royal de Bruxelles, 1991), pp. 109–10.

24 W. Thomas and L. Duerloo, *Albert et Isabelle*, exh. cat. (Brussels, Musées royaux d'Art et d'Histoire, 1998), p. 316.

25 Smolar-Meynart et al. (note 23), p. 110.

26 E. Stols, "De triomf van de exotica of de bredere wereld in de Nederlanden van de aartshertogen," in *Albert and Isabelle: Essays*, W. Thomas and L. Duerloo, eds. (Brussels, 1998), p. 298.

27 Smolar-Meynart et al. (note 23), pp. 110–11.

28 Loisel (note 21), vol. 2, p. 26.

29 Ibid.

30 For the accounts of Bergeron, Fontaine, and the Duke of Saxony, see Loisel (note 21), vol. 2, pp. 23–24.

31 "Elle a aussi chassé tous ses chiens, perroquets et guenons." As quoted in L. P. Gachard, *Lettres de Philippe II à ses filles les Infantes Isabelle et Catherine, écrites pendant son voyage en Portugal (1581–1583)* (Paris, 1884), p. 57.

32 Once again, I am grateful to John Allman for his identification of these monkeys.

33 G. Berger, *Monkeys and Apes* (New York, 1985), p. 88.

34 Jan Brueghel the Elder made a drawing entitled *Deer in the Park of Mariemont Castle*. See *Cabinet d'un amateur: Dessins flamands et hollandais des XVIe et XVIIe siècles d'une collection privée d'Amsterdam*, exh. cat. (Rotterdam, Boymans-Van Beuningen Museum; Paris, Institut Néerlandais; Brussels, Bibliothèque Albert Ier, 1976–77); and Faber Kolb (note 13), p. 10.

35 C. E. Jackson, *Dictionary of Bird Artists of the World* (Woodbridge, Suffolk, 1999), pp. 177–78.

36 Some of the Flemish colonies included Goa in India, Recife and Bahia in Brazil, Lima in Peru, and Potosí in Mexico. See Stols (note 26), p. 295.

37 See P. Smith and P. Findlen, eds., *Merchants and Marvels: Commerce, Science, and Art in Early Modern Europe* (New York and London, 2002).

38 See J. Denucé, *L'Afrique au XVIe siècle et le commerce anversois* (Antwerp, 1937), pp. 13, 15–16, 18–19, 38, 50–51, 55. See also H. van der Wee, *The Growth of the Antwerp Market and the European Economy* (The Hague, 1963).

39 C. R. Boxer, *The Portuguese Seaborne Empire 1415–1825* (London, 1969), p. 27.

40 See Gachard (note 31), p. 66.

41 E. T. Gilliard, *Birds of Paradise and Bower Birds* (London, 1969), pp. 15–16.

42 P. Delaunay, *La Zoologie au seizième siècle* (Paris, 1962), p. 33.

43 A. Gerbi, *Nature in the New World: From Christopher Columbus to Gonzalo Fernández de Oviedo* (Pittsburgh, 1985), p. 222.

44 For sixteenth- and seventeenth-century scientific collections in Italy, see P. Findlen, *Possessing Nature: Museums, Collecting, and Scientific Culture in Early Modern Italy* (Berkeley, 1996).

45 F. W. T. Hunger, *Charles de l'Escluse (Carolus Clusius) Nederlandsch kruidkundige, 1526–1609* (The Hague, 1927–43).

46 For Rudolf II's collection, see T. D. Kaufmann, *The School of Prague: Painting at the Court of Rudolf II* (Chicago, 1988); T. D. Kaufmann, *The Mastery of Nature: Aspects of Art, Science, and Humanism in the Renaissance* (Princeton, 1993); R. Bauer and H. Haupt, eds., "Die Kunstkammer Kaiser Rudolfs II in Prag, ein Inventar aus den Jahren 1607–1611," *Jahrbuch der Kunsthistorischen Sammlungen in Wien* 72 (1976), pp. vii–191; E. Fucíková, "Collection of Rudolf II at Prague: Cabinet of Curiosities or Scientific Museum?" in *The Origins of Museums: The Cabinet of Curiosities in Sixteenth- and Seventeenth-Century Europe*, O. Impey and A. MacGregor, eds. (Oxford and New York, 1985); and E. Fucíková et al., *Prag um 1600: Kunst und Kultur am Hofe Rudolfs II*, exh. cat. (Vienna, Kunsthistorisches Museum, and Essen, Kulturstiftung Ruhr Essen, 1988).

47 For early cabinets of curiosities, see J. Schlosser, *Die Kunst- und Wunderkammern der Spätrenaissance* (Braunschweig, 1978); Impey and MacGregor (note 46); L. Daston and K. Park, *Wonders and the Order of Nature, 1150–1750* (New York and Cambridge, Mass., 1998); and B. J. Balsiger, "The *Kunst- und Wunderkammern*: A Catalogue Raisonné of Collecting in Germany, France, and

England, 1565–1750" (Ph.D. diss., University of Pittsburgh, 1970).

48 For a list of zoological collectors, see H. Engel, "Alphabetical List of Dutch Zoological Cabinets and Menageries," *Bijdragen tot de Dierkunde* 27 (1939), pp. 247–346; and Hoofdredactie et al., *De Wereld binnen Handbereik: Nederlandse kunst- en rariteitenverzamelingen, 1585–1735* (Zwolle, Amsterdams Historich Museum, 1992).

49 See F. Egmond, *Een bekende Scheveninger: Adriaen Coenen en zijn Visboeck van 1578* (The Hague, 1997); and F. Egmond and P. Mason, *The Mammoth and the Mouse: Microhistory and Morphology* (Baltimore and London, 1997), pp. 23–33.

50 Findlen (note 44), pp. 171–77.

51 For a discussion of the artist as a spectator in this painting, see E. Honig, *Painting and the Market in Early Modern Europe* (New Haven and London, 1998), pp. 122–24.

52 Brueghel's drawing of the Castel dell'Ovo is in the Boymans-van Beuningen Museum, Rotterdam, and the *View of Castel Sant'Angelo and Saint Peter's* is in the Hessisches Landesmuseum, Darmstadt. See M. Winner, "Zeichnungen des Älteren Jan Brueghel," *Jahrbuch der Berliner Museen* 3 (1961), pp. 124–25.

53 See R. Schaer, ed., *Tous les savoirs du monde: Encyclopédies et bibliothèques, de Sumer au XXIe siècle*, exh. cat. (Paris: Bibliothèque Nationale de France, 1996).

54 U. Aldrovandi, MSS 41 and 110, n.d., Biblioteca Universitaria Bologna. Aldrovandi's interests were not limited to science but also included art as revealed in his *Di Tutte le statue antiche* (1556), a guide to the antique statues in Rome.

55 Medieval encyclopedias, most notably Albertus Magnus's and Thomas of Cantimpre's treatises, copied mainly the classical models of Pliny and Aristotle and did not contribute new information about species.

56 W. Ley, *Dawn of Zoology* (Englewood Cliffs, 1968), pp. 31–32.

57 J. Isager, *Pliny on Art and Society* (Odense, 1991), p. 35.

58 C. Gesner, *Historia animalium*, 4 vols. (Zurich, 1551–58); U. Aldrovandi, *Natural History*, 12 vols. (Bologna, 1599–1648). Aldrovandi's encyclopedia is usually called *Natural History*, even though the twelve volumes have different titles. For Aldrovandi, see G. Olmi, *L'inventario del mondo: Catalogazione della natura e luoghi del sapere nella prima età moderna* (Bologna, 1992), and G. Olmi, *Ulisse Aldrovandi: Scienza e natura nel secondo Cinquecento* (Trento, 1978).

59 For relevant discussions of the crucial role that images played in natural history, see C. Swan, "From Blowfish to Flower Still-life Paintings: Classification and Its Images, circa 1600," in Smith and Findlen (note 37), pp. 109–36; D. Landau and P. Parshall, *The Renaissance Print* (New Haven and London, 1994), pp. 245–59; for a discussion of Federico Cesi's natural history drawings, see D. Freedberg, *The Eye of the Lynx* (Chicago and London, 2002).

60 P. Belon, *De Aquatilibus libri duo* (Paris, 1553); and G. Rondelet, *Libri di piscibus marinis* (Lyon, 1554) and *Universae aquatilium historiae . . .* (Lyon, 1555).

61 See W. B. Ashworth, "Persistent Beast: Recurring Images in Early Zoological Illustration," in *The Natural Sciences and the Arts*, vol. 22, *Acta Universitatis Upsaliensis, Figura Nova*, ed. A. Ellenius (Uppsala and Stockholm, 1985), pp. 46–66.

62 G. F. de Oviedo, *Historia general y natural de las indias*, XII, 6: II, 62a, quoted in Gerbi (note 43), p. 229.

63 Our modern notions of classification were only introduced in 1758 by Linnaeus, who established the standard hierarchical categories of class, order, family, genus, and species.

64 Aldrovandi only published the three volumes of the *Ornithologiae* (1599–1603) and the *De Animalibus insectis libri septum* (1602) during his lifetime. The nine other books of his *Natural History* were published posthumously.

65 M. Rooses, "P. P. Rubens en Balthasar Moretus. IV," *Rubens-Bulletijn* 2 (1883), pp. 187, 189, 191; and M. Rooses, *Rubens* (London, 1904), I: 264. Rubens bought Aldrovandi's *Ornithologiae* (1599–1603), *De Animalibus insectis* (1602), *De Piscibus et de cetis* (1612), and *De Quadrupedibus solidipedibus* (1616) from Balthasar Moretus between 1613 and 1617.

66 For Nicholas de Bruyn's emblematic series of twelve animal engravings of about 1570, see Hollstein (note 6), pp. 67–78. For Collaert's prints, see the facsimile edition of the *Avium vivae icones in*

86

aes incisae et editae ab Adriano Collardo (Brussels, 1967).

67 In modern taxonomy these birds form part of the ciconiiform order.

68 In modern zoology both belong to the galliform order.

69 Delaunay, (note 42), p. 33.

70 In modern taxonomy they are part of the rodentian order.

71 T. Seibert, *Lexikon Christlicher Kunst* (Freiburg, Basel, and Vienna, 1980), p. 151. Johannes Stradanus must have been aware of this significance, since he placed a porcupine in the foreground of his highly finished drawing of *The Creation of Eve* (London, British Museum). Maarten de Vos also included the porcupine in his engraving of *The Creation of Adam and Eve*.

72 See F. Ames-Lewis, "Modelbook Drawings and the Florentine Quattrocentro Artist," *Art History* 10 (March 1987), pp. 1–11; Ames-Lewis (note 16); and R. W. Scheller, *Exemplum: Model Book Drawings and the Practice of Artistic Transmission in the Middle Ages (circa 900–circa 1470)* (Amsterdam, 1995).

73 See F. Koreny, *Albrecht Dürer und die Tier- und Pflanzstudien der Renaissance*, exh. cat. (Vienna, Graphische Sammlung Albertina, 1985); and C. Eisler, *Dürer's Animals* (Washington, D.C., and London, 1991).

74 Koreny (note 73), pp. 15–16, 136–37, 261–62; no. 43.

75 Findlen (note 44), p. 60.

76 Egmond and Mason (note 49), p. 24.

77 J. Ackerman, "The Involvement of Artists in Renaissance Science," in *Science and the Arts in the Renaissance* (Washington, D.C., and London, 1985), p. 126.

78 Leonardo, in his notebooks, cited in E. F. Rice, Jr. with A. Grafton, *The Foundations of Early Modern Europe 1460–1559* (New York, 1994), p. 21. See also J. Ackerman (note 77), "The Involvement of Artists in Renaissance Science," pp. 95, 126.

79 See Rice and Grafton (note 78), pp. 23–24; A. C. Keller, "Zilsel, the Artisans, and the Idea of Progress in the Renaissance," in *Roots of Scientific Thought: A Cultural Perspective*, P. P. Wiener and A. Noland, eds. (New York, 1957), pp. 281–86; and E. Panofsky, "Artist, Scientist, Genius: Notes on the 'Renaissance-Dämmerung,'" in *The Renaissance: A Symposium* (New York, The Metropolitan Museum of Art, 1952), p. 88.

80 See L. Hendrix, "Joris Hoefnagel and the 'Four Elements': A Study in Sixteenth-Century Nature Painting" (Ph.D. diss., Princeton University, 1984); and L. Hendrix and T. Vignau-Wilberg, *Mira calligraphiae monumenta* (Malibu, 1992).

81 Hendrix (note 80), p. 73.

82 See Kaufmann 1988 (note 46), pp. 202–203. Hoefnagel may have had exposure to Duke Wilhelm V's menagerie in Landshut, which had a large aviary and hawk house. H. Geissler, "*Ad vivum pinxit*. Überlegungen zu Tierdarstellungen der Zweiten Hälfte des 16. Jahrhunderts,"

Jahrbuch der Kunsthistorischen Sammlungen in Wien 82–83 (1986–87), p. 112.

83 See J. Spicer, "The Drawings of Roelandt Savery" (Ph.D. diss., Yale University), p. 155.

84 H. Haupt et al., *Le Bestiaire de Rodolphe II: Cod. min. 129 et 130 de la Bibliothèque nationale d'Autriche* (Paris, 1990), pp. 55–59; and Bauer and Haupt (note 46), p. 135, note 33, inv. nos. 2689 and 2690, fol. 381r.

85 For example, the portraits of birds by Fröschel correspond to the birds mentioned in the inventory. Haupt et al. (note 84), p. 40.

86 Koreny (note 73), pp. 148–49; no. 49; and L. Hendrix, "Natural History Illustration at the Court of Rudolf II," in E. Fucíková et al. (note 15), *Rudolf II and Prague: The Court and the City*, pp. 158–59.

87 James Ackerman argues that the watercolors by Dürer of individual species, which are devoid of any setting, are more empirical than a representation that includes a landscape. He considers them to be more "objective" due to their "laboratory conditions." See J. Ackerman, "Early Renaissance Naturalism and Scientific Illustration," in *The Natural Sciences and the Arts*, vol. 22, A. Ellenius, ed., *Acta Universitatis Upsaliensis, Figura Nova* (Uppsala and Stockholm, 1985), pp. 4–5.

88 K. van Mander, *The Lives of the Illustrious Netherlandish and German Painters, from the First Edition of the Schilder-Boeck (1603–1604)*, H. Miedema, ed. (Doornspijk, 1994), fol. 234r.

89 F. Grossmann, *Pieter Bruegel* (London, 1973), p. 200.

90 See W. Gibson, *"Mirror of the Earth": The World Landscape in Sixteenth-Century Flemish Painting* (Princeton, 1989); M. J. Friedländer, *Early Netherlandish Painting*, H. Norden, trans. (New York, 1967–76), vols. 9b and 13; and R. Koch, *Joachim Patinir* (Princeton, 1968).

91 F. Borromeo, *Musaeum*, translated in A. Quint Platt, *Cardinal Federico Borromeo as a Patron and a Critic of the Arts and His "Musaeum" of 1625* (New York and London, 1986), p. 236.

92 For a discussion of Dürer's *Madonna with a Multitude of Animals* and its relation to contemporary conceptions of the natural world, see also L. Silver and P. Smith, "Splendor in the Grass: The Powers of Nature and Art in the Age of Dürer," in Smith and Findlen (note 37), p. 32.

93 F. Winkler, *Dürers Zeichnungen* (Berlin, 1937), vol. 2, p. 42; and Ertz (note 1), p. 436.

94 See M. Meadow, *Pieter Bruegel the Elder's Netherlandish Proverbs* (Zwolle, 2001).

95 See H. Pirenne, *Histoire de Belgique* (Brussels, 1911), vol. 4, pp. 454–55.

96 S. Bedoni, *Jan Brueghel in Italia e il Collezionismo del Seicento* (Florence, 1983), pp. 67–71; and J. Garms, *Quellen aus dem Archiv Doria-Pamphilj: Zur Kunsttätigkeit in Rom unter Innocenz X* (Rome and Vienna, 1972), pp. 145–46. In a letter, dated March 2, 1654, Camillo wrote to the Apostolic Nuncio of Paris: "Ho quil quadro di mano di Brugle rappresentante la creatione del mondo."

The letter, which describes the work, indicates that he may have recently acquired it. Although Bedoni believes that Camillo referred to the *Terrestrial Paradise with the Temptation of Adam and Eve* in the Doria Pamphilj Gallery, it seems unlikely that a Cardinal would confuse the Temptation with the Creation. Camillo's letters as well as subsequent family inventories suggest that he acquired most of the paintings by Brueghel in the Doria Pamphilj collection today, including the set of the Four Elements.

97 J. Bono, *The Word of God and the Language of Men: Interpreting Nature in Early Modern Science and Medicine*, vol. 1 (Madison, 1995), pp. 55, 73.

98 Ibid., pp. 14, 80. See also J. Prest, *The Garden of Eden: The Botanic Garden and the Re-Creation of Paradise* (New Haven and London, 1981), p. 27; and J. M. Evans, *Paradise Lost and the Genesis Tradition* (Oxford, 1968), p. 20.

99 E. Topsell, *A Historie of Foure-Footed Beastes* (London, 1607), Epistle Dedicatory.

100 Bono (note 97), p. 21.

101 P. Belon, *L'Histoire de la nature des oyseaux* (1555), P. Glardon, ed. (Geneva, 1997), p. 3.

102 J. Browne, *The Secular Ark* (New Haven, 1983), p. 2.

103 Topsell (note 99), Epistle Dedicatory.

104 Ashworth calls their approach the "emblematic world view." See W. B. Ashworth, "Natural History and the Emblematic World View," in *Reappraisals*

of the Scientific Revolution, D. C. Lindberg and R. S. Westman, eds. (Cambridge, England, and New York, 1990), pp. 303–32; W. B. Ashworth, "Emblematic Natural History of the Renaissance," in *Cultures of Natural History*, N. Jardine et al., eds. (Cambridge, England, 1996), pp. 17–36; and Bono (note 97), pp. 20, 175.

105 See Grafton, Grafton, and Foucault (note 2).

106 Topsell (note 99), A5v.

107 Galileo, "Prima lettera circa le macchie solari" (1612), cited in A. C. Crombie, "Science and the Arts in the Renaissance: The Search for Truth and Certainty, Old and New," in *Science and the Arts in the Renaissance*, J. W. Shirley and F. D. Hoeniger, eds. (Washington, D.C., and London, 1985), p. 23.

108 See Foucault (note 2), p. 34.

109 As quoted in L. Braun, *Conrad Gessner* (Geneva, 1990), p. 15.

110 A. Blair, *The Theater of Nature: Jean Bodin and Renaissance Science* (Princeton, 1997), p. 16.

111 The botanists and herbalists Otto Brunfels, Hieronymus Bock, and Leonhart Fuchs were also Protestants. See C. Raven, *Natural Religion and Christian Theology* (Cambridge, England, 1953).

112 As cited in Braun (note 109), 15. Gesner reveals his strong religious convictions in his *Partitiones theologicae* of 1549, the only theological encyclopedia of the Reformation.

113 G. Olmi, "Osservazione della natura e raffigurazione in Ulisse Aldrovandi

(1522–1605)," *Annali dell'Istituto Storico Italo-germanico in Trento* 3 (1977), pp. 162–63.

114 For a thorough analysis of Borromeo's spiritual philosophy and views on art, see Jones (note 18).

115 Jones (note 18), pp. 9–11.

116 F. Borromeo, *I Tre libri delle laudi divine*, p. 131, translated in P. Jones, "Federico Borromeo as a Patron of Landscapes and Still Lifes: Christian Optimism in Italy circa 1600," in *The Art Bulletin* 70, no. 2 (June 1988), p. 266.

117 Jones (note 18), p. 78.

118 In *Le Piaceri*, Borromeo writes: "Solitary life preserves and nurtures a high peace. ...O you mortals, you very soon forgot your old and paternal soil! What was the first thing to greet your eyes when they were opened by God's fingers? Were they not the trees and greenery? Were you not created in the midst of this? Miserable, then, and tearful will be the condition of them who will not render any profit from, or give any sign of living in solitude...." As quoted in Jones (note 18), p. 79.

119 Borromeo discussed his appreciation of Brueghel's still lifes in his *Pro suis studiis*. See Jones (note 18), p. 208.

120 Brueghel to Borromeo, August 25, 1606; Crivelli (note 3), pp. 74–75.

121 "Per quella io son stata a Brussella per ritrare alcuni fiori del natural, che non si trove in Anversa." Brueghel to Borromeo, April 14, 1606; Crivelli (note 3), p. 64.

122 For Brueghel's early landscapes, see Ertz (note 1).

123 A. Martini, *I Tre libri delle laudi divine di Federico Borromeo: Ricerca storico-stilistica* (Padua, 1975), pp. 62–63.

124 See *Breughel-Brueghel* (note 4), p. 264.

125 See G. Strauss, "A Sixteenth-Century Encyclopedia: Sebastian Münster's Cosmography and Its Editions," in *From the Renaissance to the Counter-Reformation*, C. Carter, ed. (New York, 1965), pp. 145–63.

126 Isager (note 57), pp. 32–33.

127 Brueghel's drawing of the Castel dell'Ovo in Naples indicates that he may have visited the city. Furthermore, a document dated June 23, 1590, in Naples, states that Nicola Cristiani paid Jan Brueghel for the miniatures on Francesco Carracciolo's clock. See Bedoni (note 96), pp. 19–21.

128 Fučíková et al. (note 46), p. 47; and Haupt et al. (note 84), p. 31.

129 See W. Seipel, *Pieter Bruegel d. Ä. im Kunsthistorischen Museum Wien* (Vienna, 1997).

130 See Maeyer (note 20), p. 317: "50. Ceres mit allerlei Fruechten und den vier Elementen."

131 For a discussion of this drawing and its connection to Hoefnagel, see Faber Kolb (note 13), pp. 141–43. See also Hendrix (note 80), p. 333.

132 P. Findlen, "Cabinets, Collecting and Natural Philosophy," in E. Fučíková et al. (note 15), p. 209.

133 For Brueghel's letters regarding the various paintings of the Four Elements, see Crivelli (note 9), pp. 91–92, 104, 116–18, 139, 152–53, 162, 166–67, 184, 203–204, 238, 271–72. A set on panel in Lyon replicates the Doria Pamphilj series. The various paintings in Lyon are dated 1606, 1610, and 1611; Ertz considers them to be by Jan the Younger, but Buijs attributes them to Jan the Elder. I must reserve judgment, since I have not seen them in person. See K. Ertz, *Jan Brueghel der Jüngere, 1601–1678. Die Gemälde mit kritischem Oeuvre-katalog* (Freren, 1984), p. 68; Ertz (note 1), p. 373; and H. Buijs and M. van Bergen-Gerbaud, *Tableaux flamands et hollandais du Musée des Beaux-Arts de Lyon*, exh. cat. (Paris, Institut Néerlandais, and Lyon, Musée des Beaux-Arts, 1991), pp. 26–31.

134 For a discussion of this series, see Faber Kolb (note 13), pp. 150–59.

135 F. Borromeo, *Parallela cosmographica de sede et apparitionibus daemonum*, Ambrosiana MS Cons. M.I. 76.

136 See Jones (note 18), p. 80.

137 Jones (note 116), p. 266; and A. Falchetti, *Pinacoteca Ambrosiana* (Vicenza, 1969), p. 294. Unfortunately, this list is untraceable.

138 The flying fish, found in warm waters, builds up speed under water, and upon breaking the surface spreads its large fins and becomes airborne.

139 Rudolf's inventory of 1607–11 lists six flying fish. Haupt et al. (note 84), pp. 274–75; Cod. min. 129, fol. 89r, Österreichische Nationalbibliothek, Vienna. The flying fish also appears in Brueghel's *Allegory of the Elements* of 1604 in Vienna. He does not place it so prominently in the sky, but rather shows it flying near the reeds (see Figure 52).

140 Platt (note 91), p. 237.

141 "Raccogliere della natura tutte quelle diversita...." Brueghel to Borromeo, April 19, 1613; Crivelli (note 3), p. 204.

142 G. Ravasi, ed., *Musaeum Federico Borromeo* (Milan, 1997), p. 29; and Platt (note 91), p. 238.

143 Martini (note 123), p. 267.

144 For discussions of these paintings see J. Müller-Hofstede, "'Non Saturatur Oculus Visu'—Zur 'Allegorie des Gesichts' von Peter Paul Rubens und Jan Brueghel d. Ä.," in *Wort und Bild in der Niederländischen Kunst und Literatur des 16. und 17. Jahrhunderts*, J. Müller Hofstede and H. Vekeman, eds. (Erftstadt, 1984), pp. 243–90; M. Díaz Padrón, *David Teniers, Jan Brueghel y los gabinetes de pintura*, exh. cat. (Prado, Madrid, 1992); and V. Stoichita, *The Self-Aware Image: An Insight into Early Modern Meta-Painting* (Cambridge, England, 1997).

145 *MS Aldrovandi*, 21, vol. 4, c. 72, Biblioteca Universitaria Bologna, quoted in Findlen (note 44), p. 206.

146 See C. Nordenfalk, "The Five Senses in Flemish Art before 1600," in *Netherlandish Mannerism*, G. Cavalli-Björkman, ed. (Stockholm, 1985), pp. 135–54. For Maarten de Vos's prints of the Five Senses, see Hollstein (note 6), vol. 46, nos. 1486–1500.

147 J. Denucé, *Brieven en Documenten betreffend Jan Brueghel I en II* (Antwerp, 1934), p. 71.

148 Brueghel represents Maximilian I's armor. See B. Welzel, "The Sense of Touch from the Five Senses of Jan Brueghel and Peter Paul Rubens," in Thomas and Duerloo (note 26), pp. 99–101.

149 K. van Mander, *Den Grondt der edel vry schilderconst (1608)*, H. Miedema, ed. (Utrecht, 1973), 9:15; as translated by E. Honig et al., *The Foundation of the Noble Free Art of Painting* (1985).

150 Van Mander (note 149), 9:16.

151 See W. Liedtke, *The Royal Horse and Rider: Painting, Sculpture, and Horsemanship, 1500–1800* (New York, 1989). Earlier examples of gray horses attest to their high status: Alexander the Great's horse, Bucephalus, was apparently gray; Raphael's fresco of *Leo the Great Meeting Attila* in the Stanze of the Vatican shows Pope Leo riding a gray horse. Indeed, during the Middle Ages, popes and bishops rode such gray steeds in processions as a symbol of their authority. In the Apocalypse of John, Christ rode a gray horse in triumph over the devil. Seibert (note 71), pp. 253–54.

152 Rubens to Sir Dudley Carleton, April 28, 1618. R. Magurn, ed. and trans., *The Letters of Peter Paul Rubens* (Cambridge, Mass., 1955), p. 60; J. Held, "Rubens's Leopards—A Milestone in the Portrayal of Wild Animals," *M27* (Montreal Museum of Fine Arts, Winter 1975), pp. 5–7; and M. Corbeil et al., "The 'Leopards' in Montreal: An Attribution to Rubens Disproved," *The Burlington Magazine* CXXXIV (1992), p. 724.

153 I am grateful to Jørgen Wadum for alerting me to this recent confirmation of the date on the Doria Pamphilj painting. See E. Safarik and G. Torselli, *La Galleria Doria Pamphilj a Roma* (Rome, 1982), p. 110, no. 173. Julius Held was unaware of the Getty *Entry of the Animals into Noah's Ark* at the time of his publications (see below). He originally dated these works to about 1615 based on the date of *The Entry of the Animals into Noah's Ark* in the Wellington Museum, London. However, after I carefully examined the date of the Getty painting with him in 1994, he altered his dating. Jaffé dated Rubens's preparatory drawings 1614–15. See J. Held, *Rubens: Selected Drawings* (London, 1959), nos. 83, 85; and M. Jaffé, "Rubens en de leeuenkuil," *Bulletin van het Rijksmuseum* 3 (1955), p. 59. Rosand dated *Daniel in Lion's the Den* to 1612–14. See D. Rosand, "Rubens's Munich Lion Hunt: Its Sources and Significance," *Art Bulletin* 51 (1969), p. 34.

154 See J. Müller Hofstede, "Die frühen Reiterbildnisse," in *Peter Paul Rubens*, exh. cat. (Cologne, 1977), pp. 84–93.

155 J. Müller Hofstede, "Rubens' Saint Georg und seine frühen Reiterbildnisse," *Zeitschrift für Kunstgeschichte* 28 (1965), pp. 91–92. The frontal position of the horse was probably derived from Tintoretto's *Entry of Philip II into Mantua* from his Gonzaga cycle, which Rubens saw in the Palazzo Ducale in Mantua. He may have also referred to the title page of Antonio Francesco Oliviero's *Carlo Quinto in Olma* (1567), representing a triumphal arch framing an equestrian portrait of Charles V, who is depicted frontally. Rubens was surely familiar with other noteworthy equestrian models, such as Johannes Stradanus's print series entitled *The Twelve Caesars* (circa 1590), which was inspired by ancient examples.

For illustrations of these works, see W. Liedtke (note 151).

156 See Glück (note 12), pp. 39–40.

157 There is a photo in the Witt Collection (Courtauld Institute, London) of a drawing of Albert on horseback attributed to Brueghel (H. Reitlinger Collection, London).

158 Borromeo probably commissioned the painting, since Brueghel made a preparatory drawing for him. See Crivelli (note 3), pp. 136, 139, 146, 148, 167, 175.

159 Brueghel painted another version of *Daniel in the Lion's Den* (Melzi collection, Milan). G. Ravasi, M. Rossi, and A. Rovetta, *The Pinacoteca Ambrosiana* (Milan, 1997), p. 134.

160 Planiscig suggests that this sculpture, which is a replica of a work by Giambologna, may be after an antique bronze. L. Planiscig, *Die Bronzeplastiken* (Vienna, 1924), p. 163, no. 266. Rubens owned a bronze statuette of a lion attacking a horse from the workshop of Giambologna and Susini, which served as a starting point for some of his hunting scenes. A. Balis, *Rubens' Landscapes and Hunting Scenes*, vol. 18 of *Corpus Rubenianum Ludwig Burchard* (London, Oxford, and New York, 1986), p. 61.

161 J. Rosenberg, "Eine Rubens-Zeichnung nach einer Tierbronze des 16. Jahrhunderts," *Pantheon* 7 (1931), pp. 105–106; and Held (note 153), no. 83.

162 For Rubens's theories of imitation, see J. Muller, "Rubens's Theory and Practice of the Imitation of Art," *The Art Bulletin* 64 (June 1982), pp. 229–47.

163 Van Mander (note 149), 9: 37–41.

164 J. C. Weyerman, *De Levens-beschryvingen der Nederlandsche Konst-schilders en Konst-schilderessen* (The Hague, 1729), vol. 1, pp. 287–89.

165 See Brenninkmeyer-De Rooij (note 1).

166 See Ashworth (note 61), pp. 46–66.

167 See Swan (note 15), pp. 353–72.

168 F. van Noten, "The Horses of Albert and Isabella: Historical Background," in Thomas and Duerloo (note 24), pp. 343–45.

169 See Thomas and Duerloo (note 24), pp. 78–79, no. 83.

170 See I. Q. Regteren Altena, *Jacques de Gheyn: Three Generations* (The Hague and Boston, 1983); and Spicer (note 83), p. 149.

171 K. van Mander, *Het Schilder-boeck*. Reprint of the 1604 edition by P. van Wesbusch, Haarlem (Utrecht, 1969), fol. 294v.

172 See Van Noten (note 168), p. 343; and A. F. Walther, *Hans Georg Ernstingers Raisbuch* (Tübingen, 1877), p. 234.

173 Cited by C. Terlinden, *L'Archiduchesse Isabelle* (Brussels, 1943), p. 57.

174 Van Noten (note 168), p. 344.

175 See *Breughel-Brueghel* (note 4), p. 21.

176 For Van Dyck's equestrian portraits, see C. Brown and H. Vlieghe, *Van Dyck* (London, 1999), pp. 85, 98–99, 197–98.

177 The painting was at one point in the Hardcastle Collection in Hawkhurst, Kent.

Speth-Holterhoff suggests possible identifications for two of the men in the painting: Ambrosius Spinola, general of the Spanish forces in the Netherlands, and Don Diego Messia, Marquis of Léganès and Philip IV's chamberlain and commander of artillery of the Netherlandish cavalry; he visited Brussels for a few months in 1627. She identifies them based on their portraits by Rubens. S. Speth-Holterhoff, *Les Peintres flamands des cabinets d'amateurs au XVIIe siècle* (Brussels, 1957), pp. 108–10.

178 The prospect of a permanent peace with the North is reflected in some of the Archdukes' projects. For example, their decoration of the important pilgrimage church in Scherpenheuvel involves a sculptural program that symbolizes peace. See C. Banz, "*Pax—Liberalitas—Pietas*: Anmerkungen zum Ausstattungs-programm der Marienwallfahrtskirche in Scherpenheuvel," in Thomas and Duerloo (note 24), pp. 161–62. Werner Thomas writes that paintings of allegories of the elements were in demand during the Truce period. These bountiful scenes were supposed to reflect the optimisim of the Archdukes and their Flemish subjects by referring to better times, rather than the previous years of war. See W. Thomas, "Andromeda Unbound: The Reign of Albert and Isabella in the Southern Netherlands, 1598–1621," in Thomas and Duerloo (note 24), p. 8.

179 Some of Rubens's works reflect his optimistic view of the future of the Netherlands. For example, his *Farm at Laken* (circa 1618, Royal Collection, London) with its verdant landscape and

a girl carrying a large basket of fruit, alludes to the prosperity of the Southern Netherlands and the fertility of its rulers. The Church at Laken (restored by the Archdukes after its desecration by the Calvinists in 1581) in the background of Rubens's painting held great significance for the Archdukes. Because its miracle-working relic of a ribbon was believed to make barren women conceive, Isabella made frequent trips to the church where she tied the ribbon around her belly in the hope that she would produce an heir. Although Isabella never conceived a child, the prospect of a productive and stable future for the Southern Nether-lands under the sovereign rule of the Archdukes' heirs continued until the death of Albert in 1621. See C. Brown, "Rubens and the Archdukes," in Thomas and Duerloo (note 24), p. 125.

180 For the print of *Leo Belgicus* by Claes Jansz. Visscher of circa 1611–21, see Thomas and Duerloo (note 24), pp. 116–17.

181 In ancient Rome certain animals used for staged combats represented defeated territories. See M. Iriye, "Le Vau's Menagerie and the Rise of the Animalier: Enclosing, Dissecting, and Representing the Animal in Early Modern France" (Ph.D. diss., University of Michigan, 1994), pp. 9–10.

182 C. Farago, *Reframing the Renaissance: Visual Culture in Europe and Latin America, 1450–1650* (New Haven, 1995), p. 219. Farago describes the important role that the Medici's collection of animals played as a cultural symbol.

183 See Welzel (note 148), pp. 99–106.

184 See A. Faber Kolb, "Varieties of Repetition: 'Trend' versus 'Brand' in Landscape Paintings by Joachim Patinir and His Workshop," *The Journal of Medieval and Early Modern Studies* 28, no. 1 (Winter 1998), pp. 167–200.

185 I am grateful to Fabry Eszter at the National Museum in Budapest and Tiarna Doherty, Assistant Conservator of Paintings at the J. Paul Getty Museum, for providing me with the measurements and tracings of these motifs.

186 The measurements of the Budapest panel (61 × 90.2 cm) are slightly larger than those of the Getty painting (54.6 × 83.8 cm). The later additions on the upper and lower edges of the Budapest panel measure 37 mm each, the section on the left is 16 mm, and the one on the right is 16–18 mm.

187 I examined this painting in 1993 with Yvonne Szafran, Associate Conservator of Paintings at the Museum, using infrared reflectography.

188 Van Mander (note 149), *Den Grondt*, 5 : 11–12. See also Taylor (note 1), *Dutch Flower Painting*, p. 92.

189 Jørgen Wadum has demonstrated that Brueghel came up with the composition for the Mauritshuis painting, since the underdrawing is by him. Brueghel then had Rubens paint the figures, horse, and Tree of Wisdom, and only thereafter did Brueghel paint the landscape and animals. See J. Wadum, "Het laatste nieuws uit het paradijs," *Mauritshuis in Focus* 1 (The Hague, 2001), pp. 23–30; and J. Wadum,

"Latest News from Paradise: A Preliminary Attempt to Identify Rubens's Studio Practice, Part II," in *Preprints of the Thirteenth Triennial Meeting of ICOM-CC, Rio de Janeiro* (2002), pp. 473–78.

190 Another workshop replica from the Prado (presently in Museo Municipal di Jativa) is by a different hand from the one in the Lazaro Galdiano painting. Most of the animals and birds lack detail, and the tree formation in the center has an awkward appearance. There are also two replicas by Jan Brueghel the Younger in the Musée des Beaux-Arts d'Orléans (see *Mémoire du nord*, exh. cat. [Musée des Beaux Arts d'Orléans, 1996] and sale cat., Christie's, Monaco, December 7, 1991). Work-shop copies can be found in the Rocky Mountain Conservation Center in Colorado, the Gemäldegalerie in Dessau, the collection of the Earl of Verulam in England, and the Palacio del Marques de Viana in Cordoba. Frederick Bouttats (active in Antwerp circa 1612–61) imitated this work as well (see sale cat., Sotheby's, New York, January 14, 1993, lot 22).

191 Ashworth (note 61), pp. 46–66.

192 See S. Alpers, *The Art of Describing* (Chicago, 1983), xxiv.

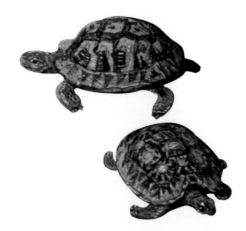

Index

Note: Page numbers in *italics* indicate illustrations.

Acknowledgments

My research on Jan Brueghel's paradise landscapes grew out of five years of practically living with *The Entry of the Animals into Noah's Ark* in the J. Paul Getty Museum. The more I studied the painting the more I realized how little we knew about the artist, in particular his approach to nature. Over the years, I have consulted many relevant scholars to whom I am grateful for their expertise. I have benefited from the invaluable advice of Elizabeth Honig, Todd Olson, John Pollini, and Paul Knoll. I am particularly grateful to Claudia Swan and Christopher White, who agreed to read and comment on the text at an early stage. Yvonne Szafran, Tiarna Doherty, Fabry Eszter, and Jørgen Wadum provided me with important technical information on the Getty, Budapest, and Mauritshuis paintings. For information on zoological collections in the Netherlands and Italy, I consulted Fernand Schrevens, the curator of the Antwerp Zoo library, Arthur MacGregor, Lucia Tongiorgio Tomasi, and Paula Findlen. I am grateful to David Rimlinger, Curator of Birds at the San Diego Zoo, and John Allman, Professor of Neurobiology at the California Institute of Technology, for their assistance with the identifications of animals and birds. I have also benefited from numerous discussions with Lee Hendrix, Michael Jaffé, David Jaffé, Julius Held, Fritz Koreny, and Melanie Gifford.

I am extremely grateful to the publications and curatorial staff at the J. Paul Getty Museum: Jeffrey Cohen, Mark Greenberg, Suzanne Watson, Scott Schaefer, Anne Woollett, and Jean Linn. Mollie Holtman, in particular, made the editorial process so pleasant for me.

The research for this book was made possible by various travel grants from the J. Paul Getty Museum and a fellowship from the Borchard Foundation and the Art History Department of the University of Southern California (I am grateful to Eunice Howe for nominating me for the fellowship). I would also like to mention the people who assisted me with my research: Eva Irblich, Christine Eckelhardt, Chris Stevens, Sabine van Sprang, Nadine Orenstein, Arthur Wheelock, Gregory Jecmen, Ildikó Korösi-Ember, Edwin Buijsen, and the staff of the Biblioteca Ambrosiana.

I fondly acknowledge my family, in particular my husband, Christophe, who has been a constant source of support. Finally, I dedicate this book to my son Maximilian, who was created at the same time.